# THEORY of WANTS

Ohad Maiman

[DAMIANI]

[DAMIANI]

**Damiani editore**
Via Zanardi 376, 40131 Bologna, Italy
tel +39 051 6350805, fax +39 051 6347188
info@damianieditore.it
www.damianieditore.com

**THEORY of WANTS**
Ohad Maiman

Edited by Carlo Zeitschel
Foreword by Carlo Zeitschel

Design by Arnoud Verhaeghe

ISBN 978-88-6208-059-0

Printed in June 2008 by Grafiche Damiani, Bologna.

## ACKNOWLEDGMENTS

Special thanks to my parents, for teaching me that every person is an entire world onto itself, complete with unique hopes, fears, wants and drives.

To my brother and sister, for always being there for me in a world where very few people are there for anyone else.

And to my few closest friends, for being a second family.

FOREWORD

This book is in many ways a personal exploration of early adulthood and
almost a coming of age story of sorts, it is thus important to know a little
about the author. After serving three years in the special forces of the
Israeli army, and subsequently traveling extensively throughout the Far East
and South America, Ohad moved to New York to begin his studies at Columbia
University. The contrast between the comfort and care freeness of his
adolescence, to the violence and outrage of armed conflict, to the exotic lure
and enchanting peace of a village on a far away mountain forgotten by time,
provided the context for him to start questioning himself and what he wanted,
and what everyone else did for that matter...

Before long he switched his concentration from business and economics to
visual arts and philosophy. We met soon after graduating when I moved to New
York to open an art gallery. We've been very good friends since, so I've had
ample chance to witness first hand much of Ohad's ideological journey, whether
it be good old crazy life in New York or traveling around Sri Lanka
to roaming the desert at Burning Man.

This three-part book strives to analyze what it is like to live our twenties in today's world. In a society where everything is at one's fingertips and people's wants and desires seem to be growing ever more contorted, it becomes increasingly difficult to find your place in the world without the eerie feeling of being manipulated into conformity. I think it's fair to say most people spend their twenties trying to figure out what they want to do with their lives, or at least witnessing what they do and do not want to become. Everyone wants to be happy, but few actually ever stop to question whether they are or not, or if whatever it is they're doing with themselves will ever even lead them there.

People become trapped in various frames of perception, whether they are born into them or think they're just trying to do the "right thing"; the world can become a very different place from one moment to the next when you chose to change the fundamental paradigms by which you interact with it. Just like beauty is in the eye of the beholder, some realities only become plain to you when they are unlocked by certain moments when you feel them profoundly and see them so vividly.  These images are in a way his personal revelations, a collection of instances and sentiments that helped shape and express his sense of wonderment and unrest, and the pressing call for a freer more serene existence.

Carlo Zeitschel

WONDER

WONDER

If you ever went a step back and took a fresh, hard, questioning look at
everything; whether around the world or around the corner; set aside the
time to wander...or the patience to wonder...You may recognize some of the
following images.

Whether it is because you decipher my story, make up your own, or truly let
all guards down and see how comfortable or defensive, empathic or indifferent,
widely different forms of existence make you feel.

You may come to wonder how come we keep chasing and guessing the meaning
of life while all along it is staring us in the face; most often in the
smile of our child or lover.

You may come to wonder how all of us animals sharing this world have managed
to create a society and ideals greater than ourselves.

You may come to wonder how with so many simultaneously coexisting realities we
all actually manage to communicate, and coexist.

I am not yet sure why everything is, but I am sure it is spectacular.

a split second you can see life and earth move in fast motion and
allow immeasurable time.

ople are being born, going to school; and the world catapults a few
ndred spins. People are getting careers, getting married; and another
w hundred spins swish away. People are having children, raising them,
ing.

d the bastard just keeps spinning.

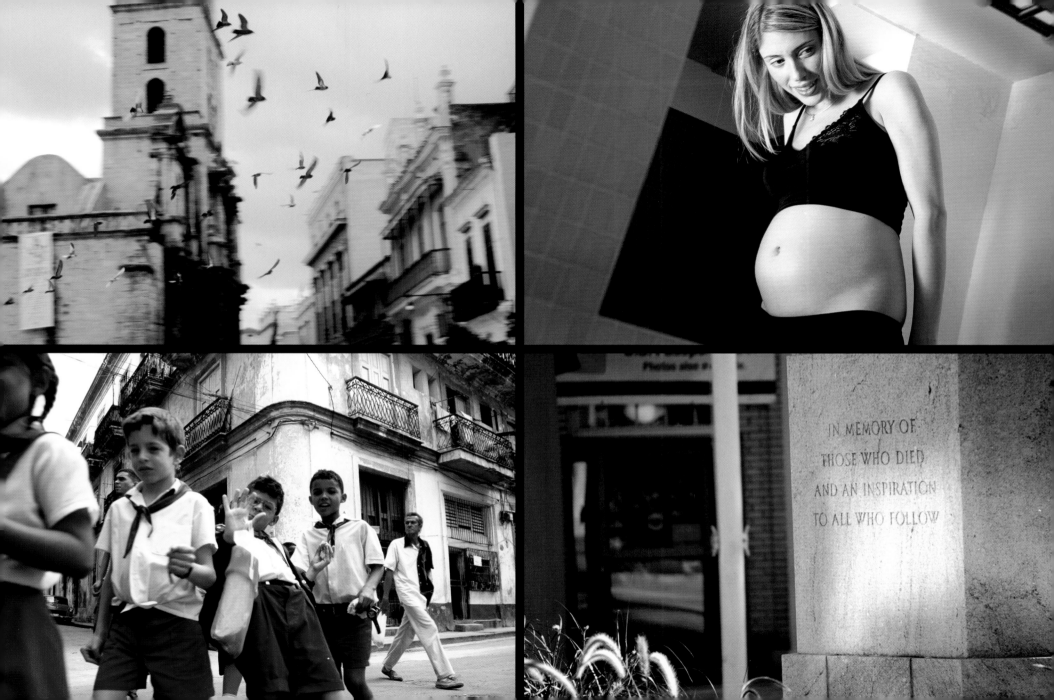

IN MEMORY OF
THOSE WHO DIED
AND AN INSPIRATION
TO ALL WHO FOLLOW

Sometimes we have to get away because the volume of those stories of lives flashing and gliding past our sights, flooding our consciousness with their pain and glory, becomes too loud to bear.

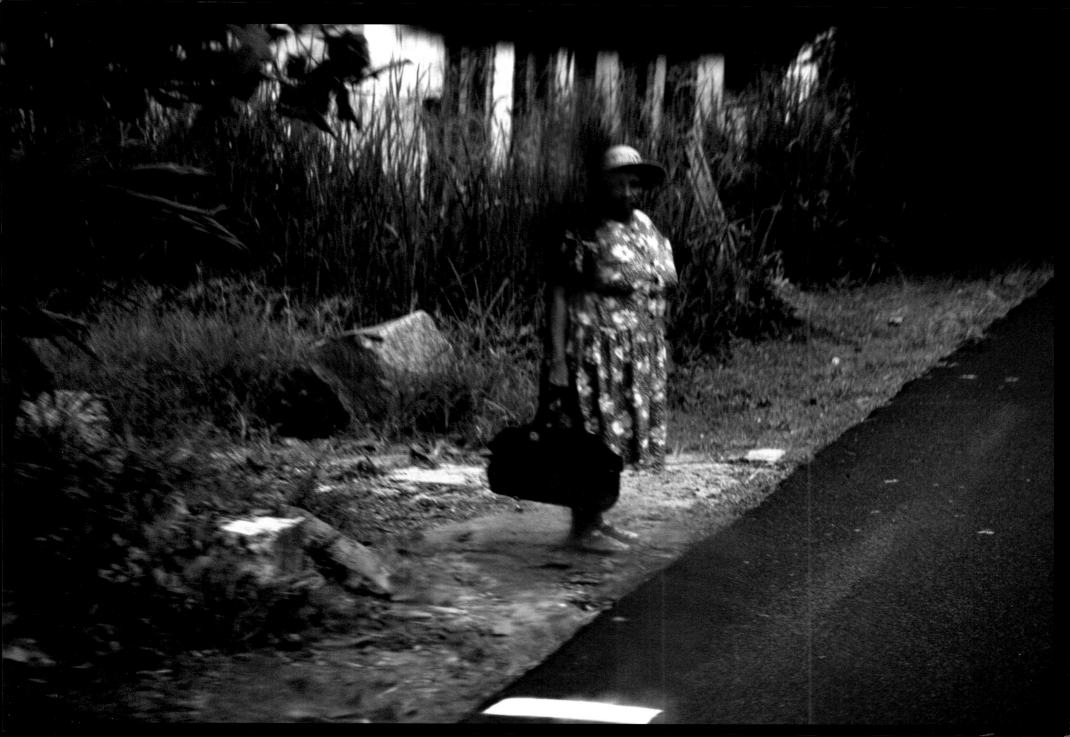

"Relative" is the name of the sickness.

Once we got a glimpse of endless possibilities, we severely hurt
our chances of achieving unquestionable happiness.

There once was a fisherman's village where the locals lived for
hundreds of years feasting on the fruitful ocean, celebrating their
local customs, living prosperously for generations upon generations. It
was a happy village, and its people have always considered themselves
lucky.

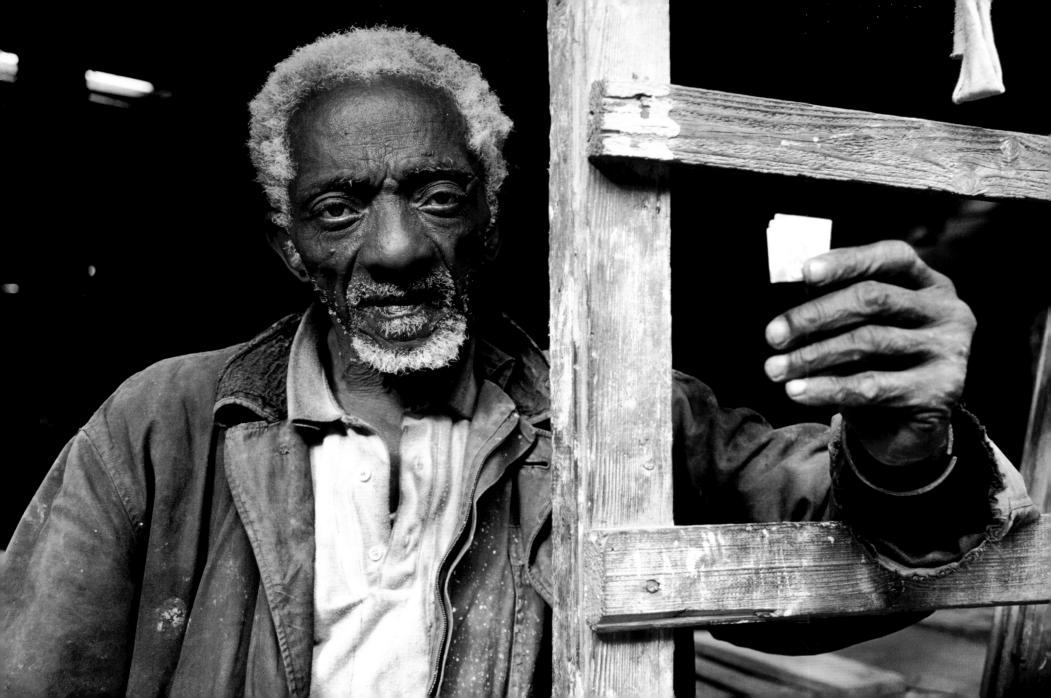

Until one day...a young entrepreneur from the capital comes by
and hooks them up to cable.

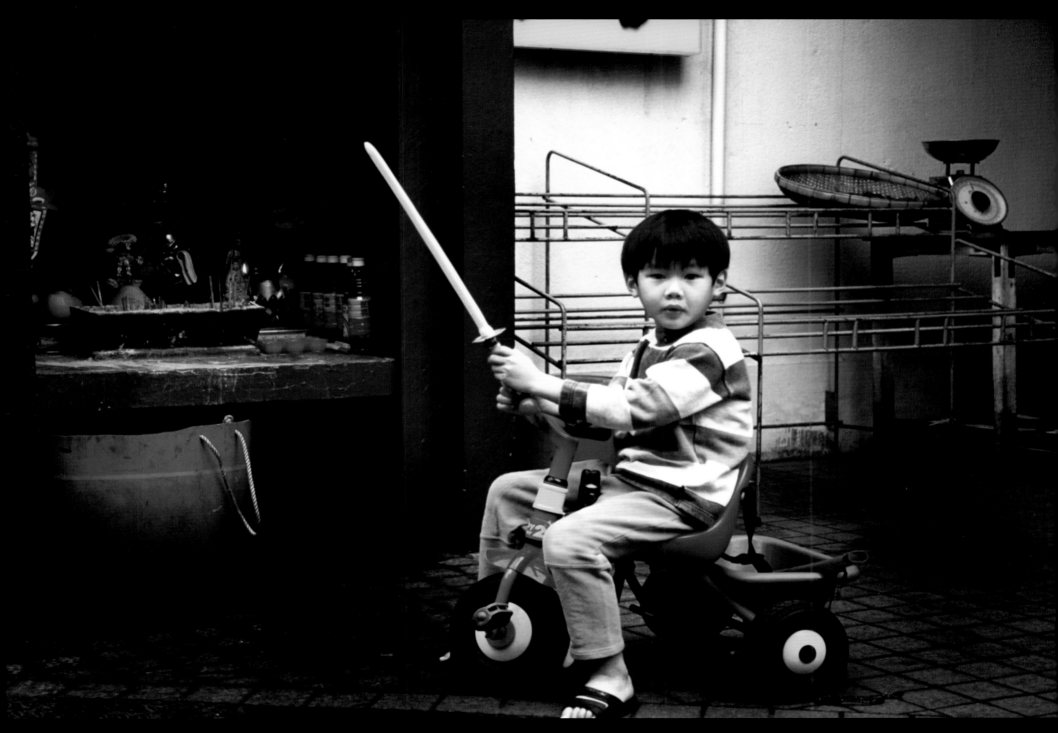

e moment they watch "The rich and famous", they discover
at they're poor.

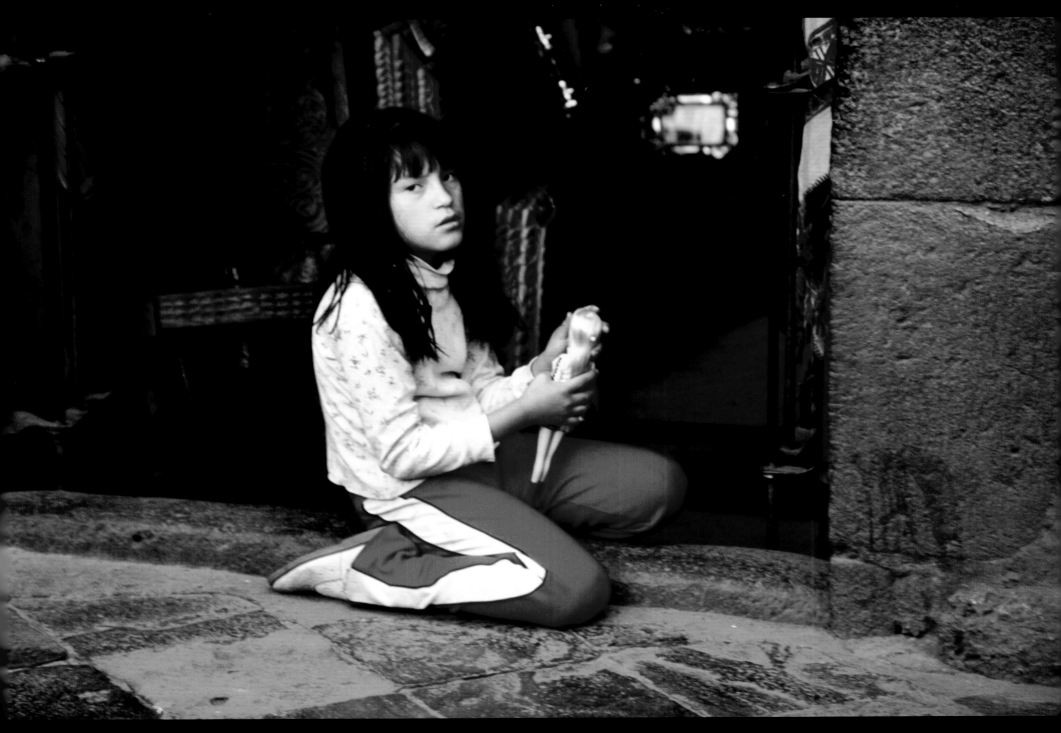

Life can get strange when you are un-indoctrinated.

When everyone around you is busy as those Japanese videos of beehive-
human-streams in packed subways and hole-in-the-wall bunk beds,
running off to those important things they must do...

How can you figure that single goal worthy of subjugating you for the
rest of your life?

Altruism is nice, but it hasn't been around much lately.

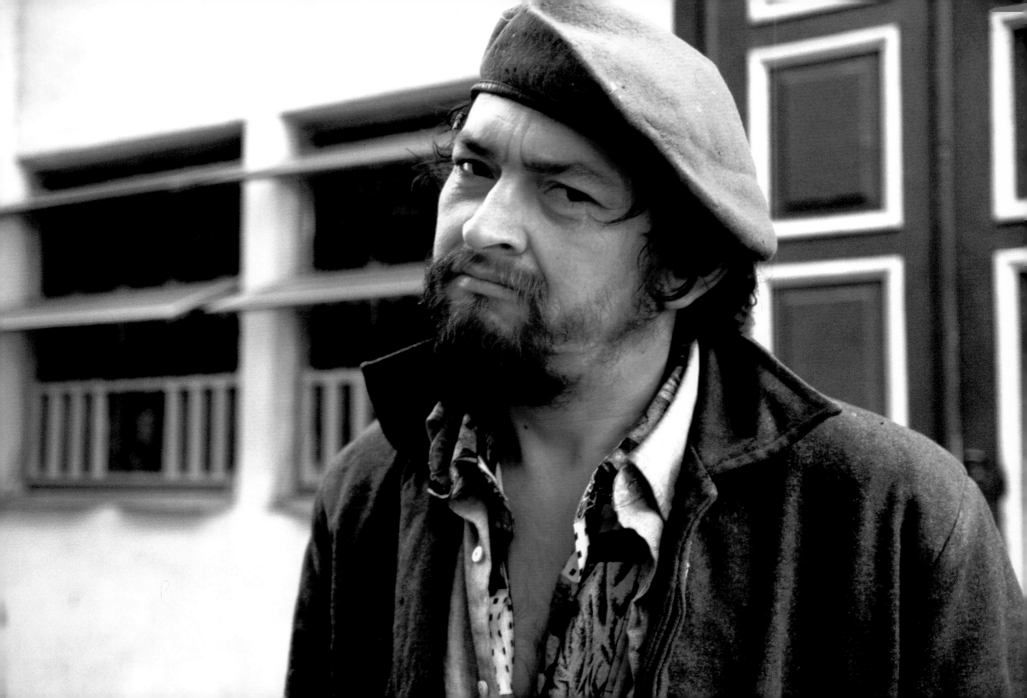

Feels as if we're born into a play, cast by chance, directed by the latest in collective consciousness.

And we swallow it whole, internalize everything we've been born into, repeat and uphold it as if it was our own.

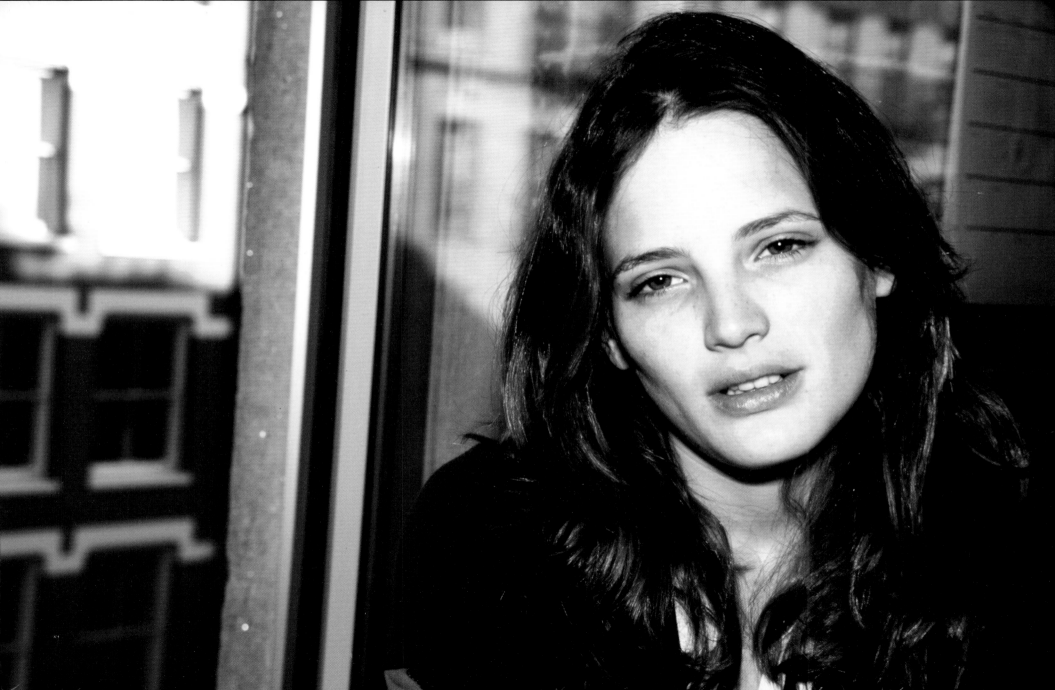

What do you think it's all about?

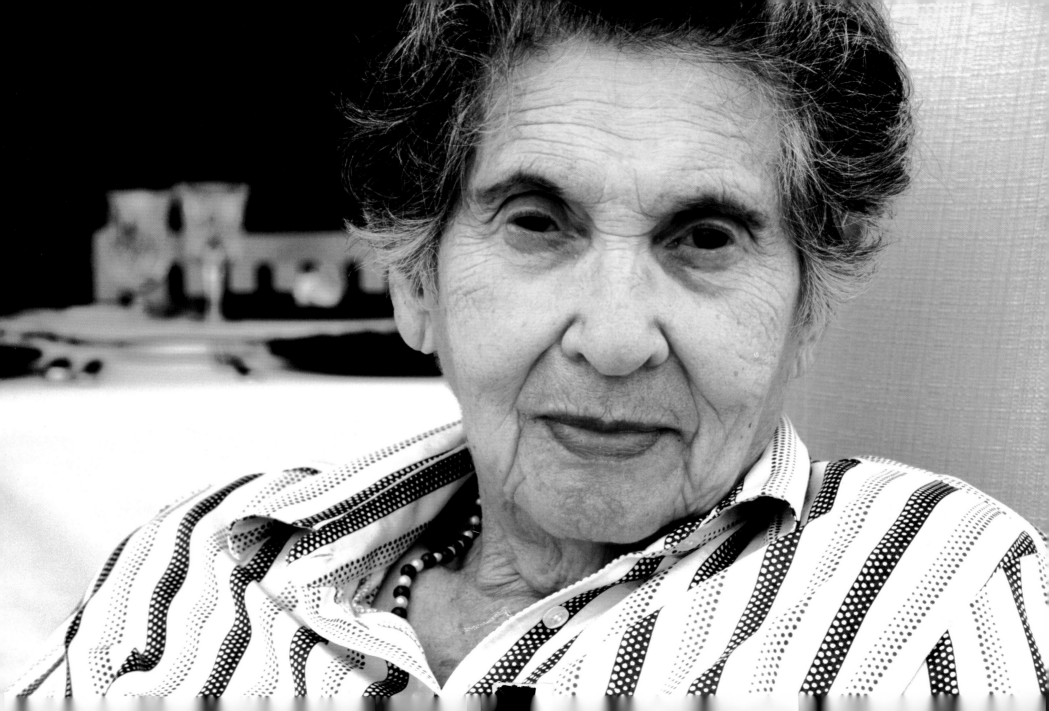

Maybe it's about love

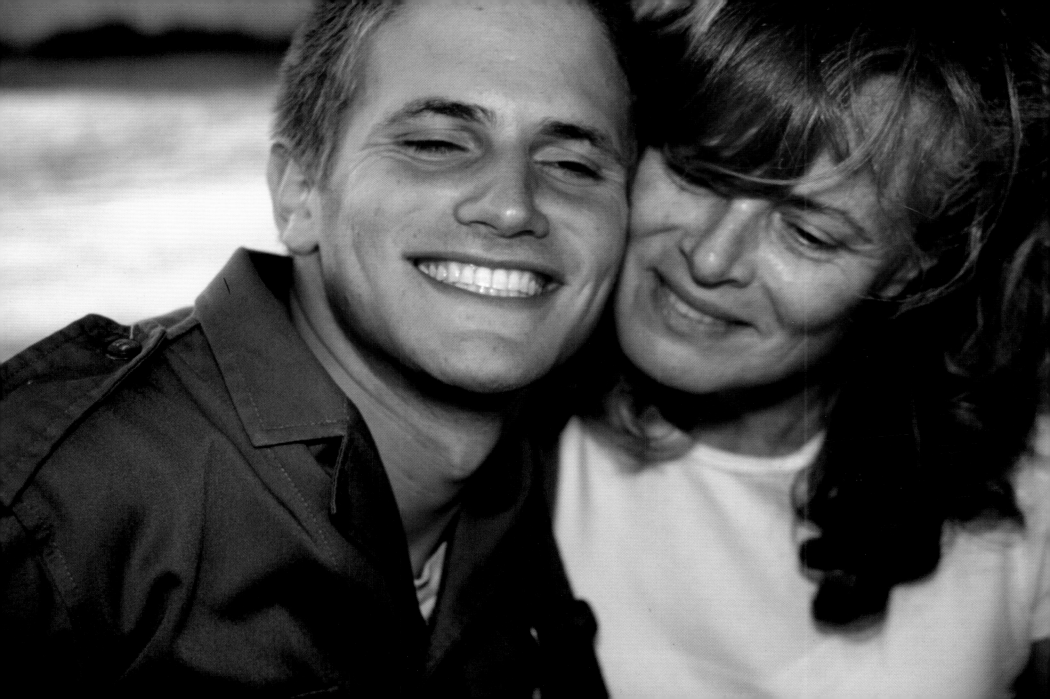

Maybe it's all about friendship

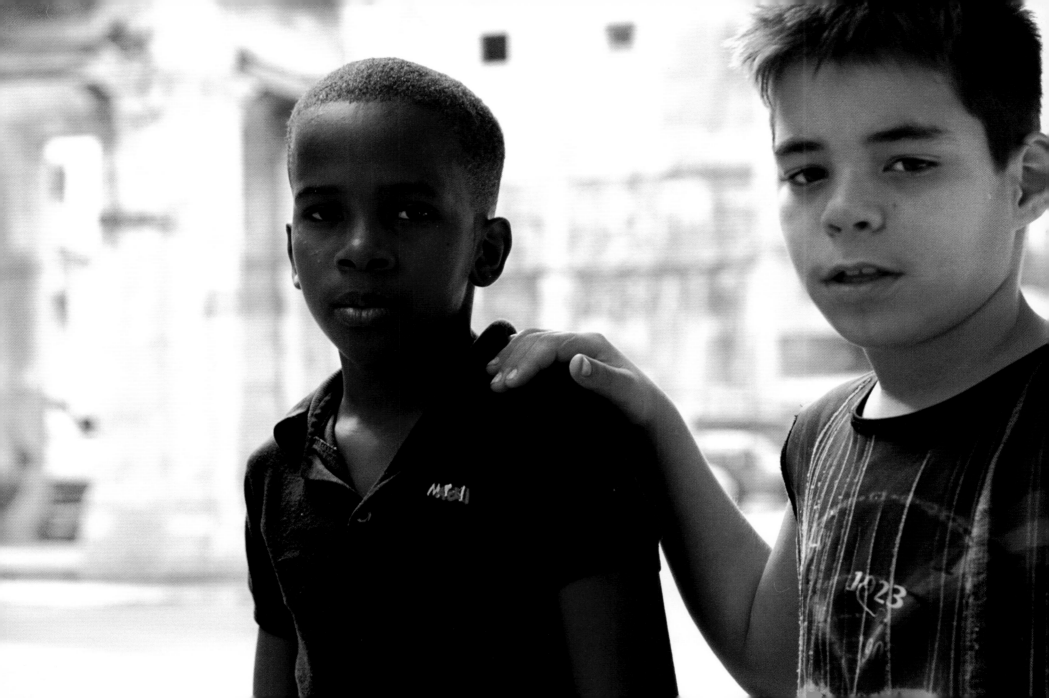

Maybe he knows?

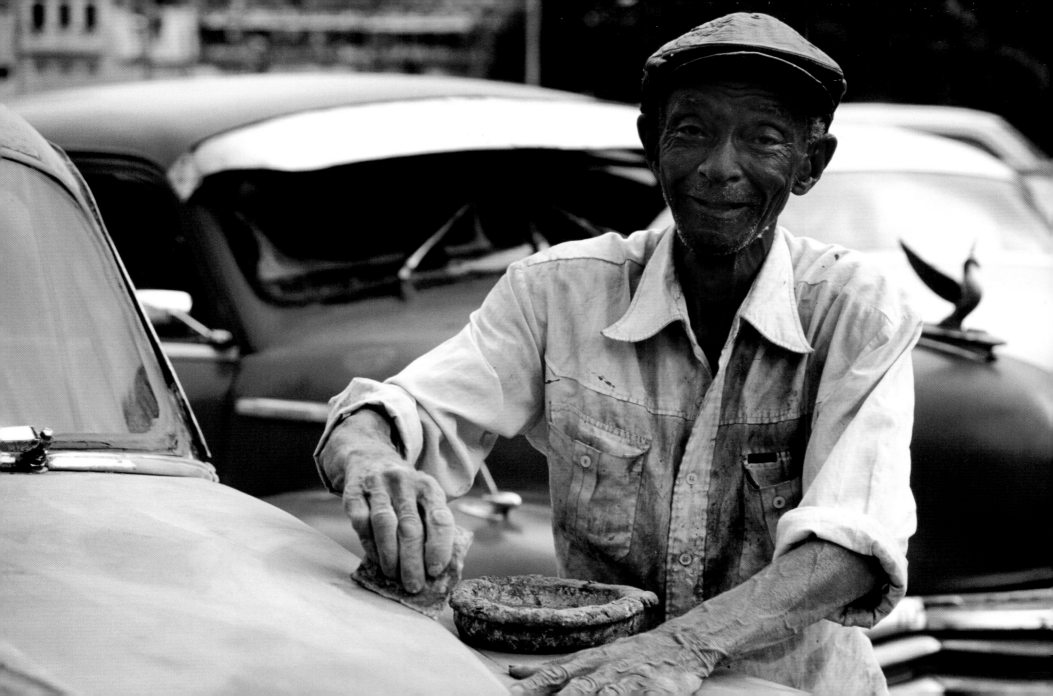

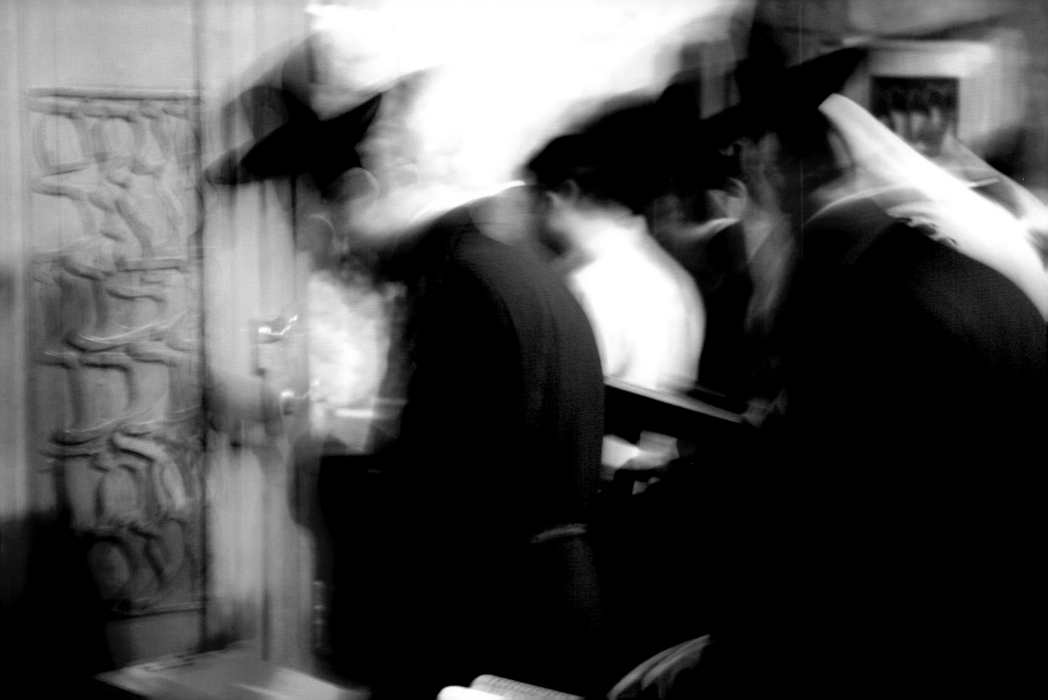

or they do...

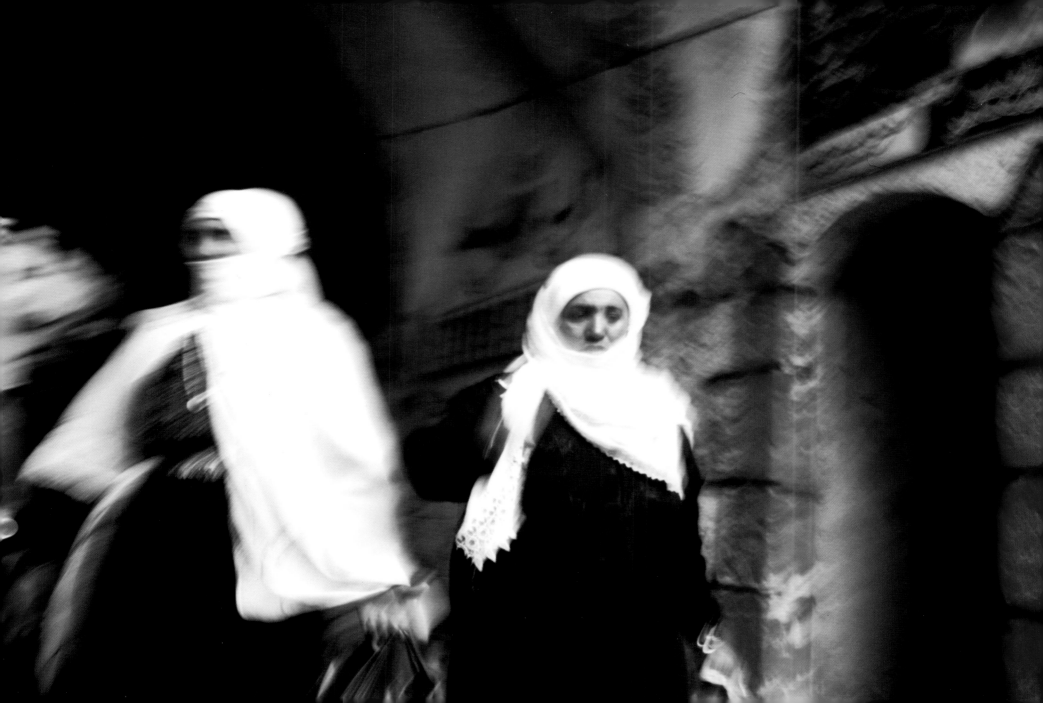

Maybe we need to make it up ourselves

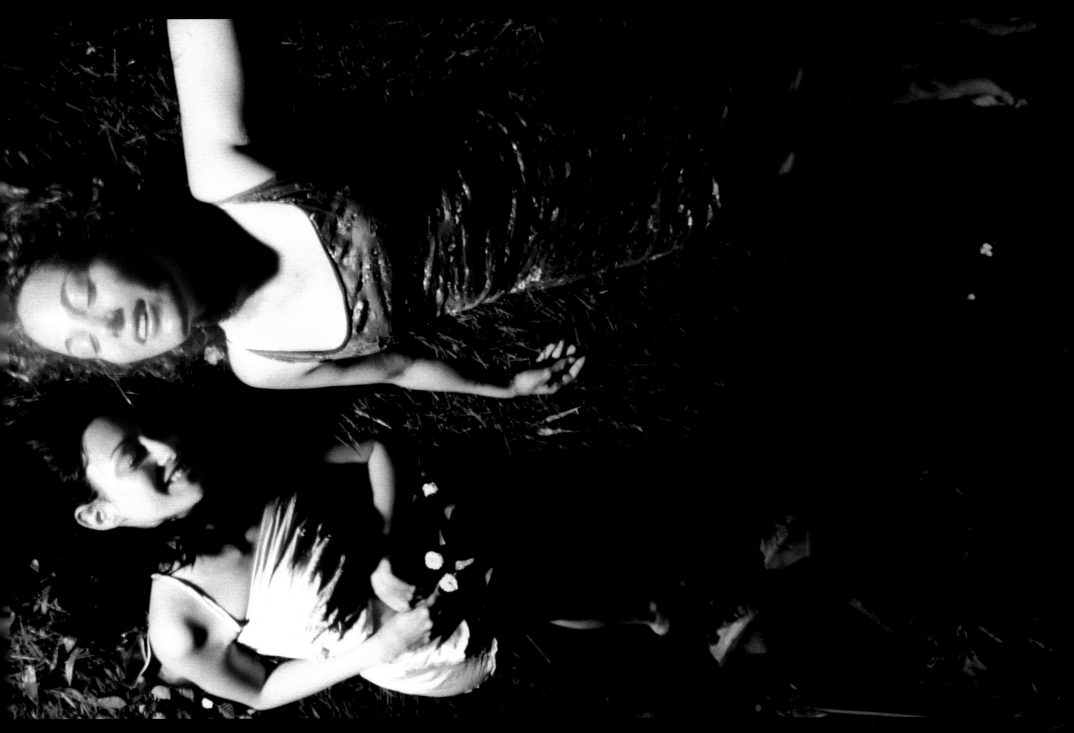

there is so much...

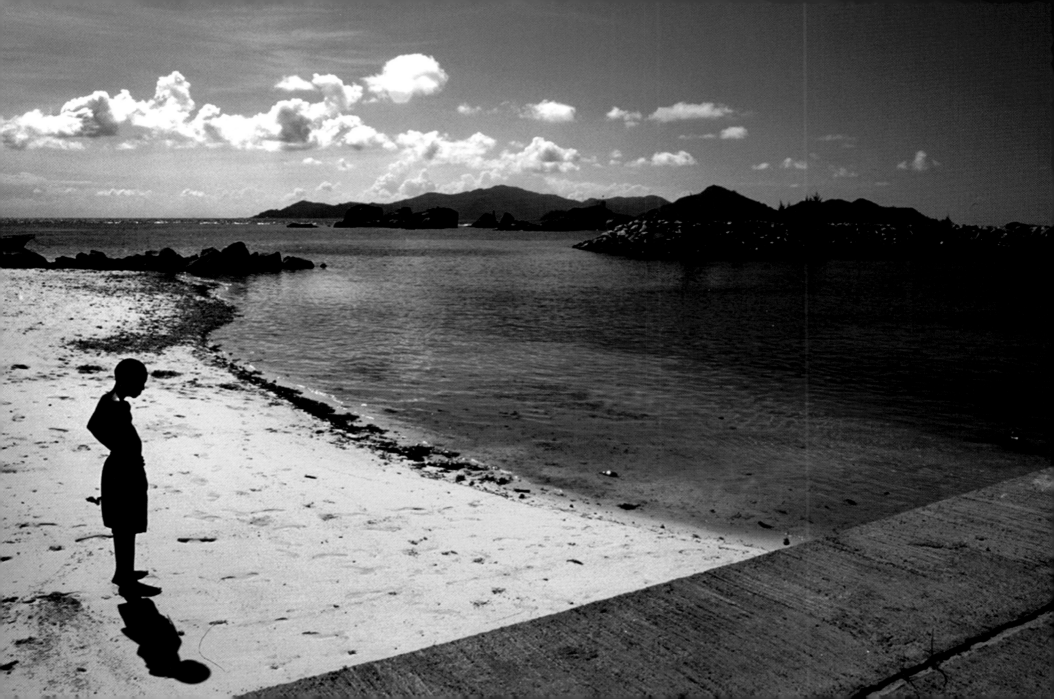

To fight for

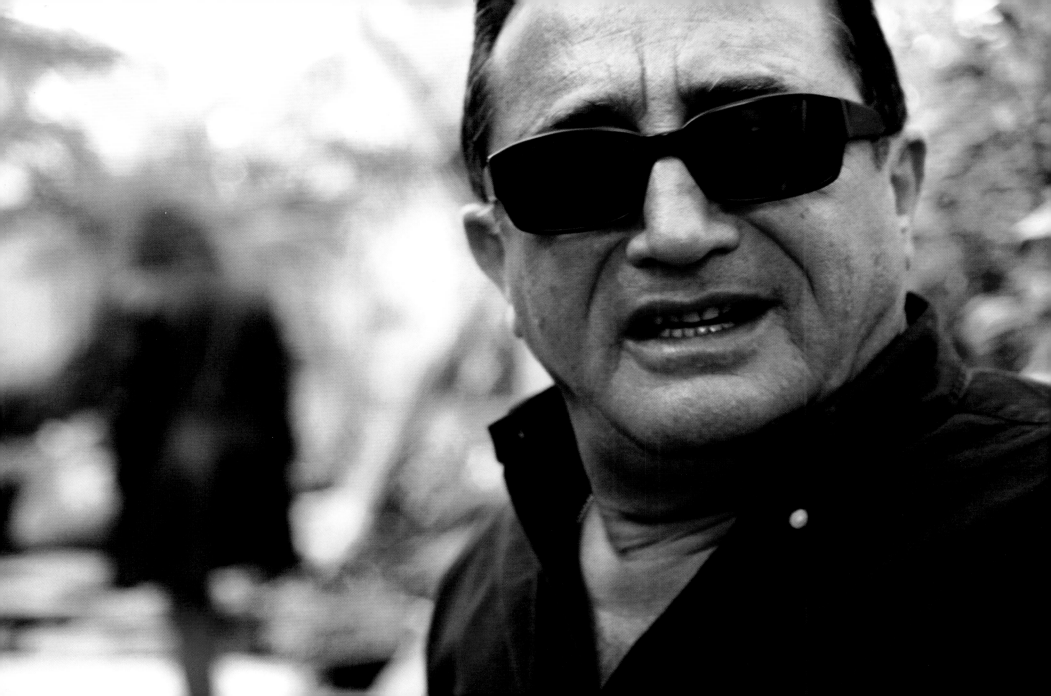

To inspire

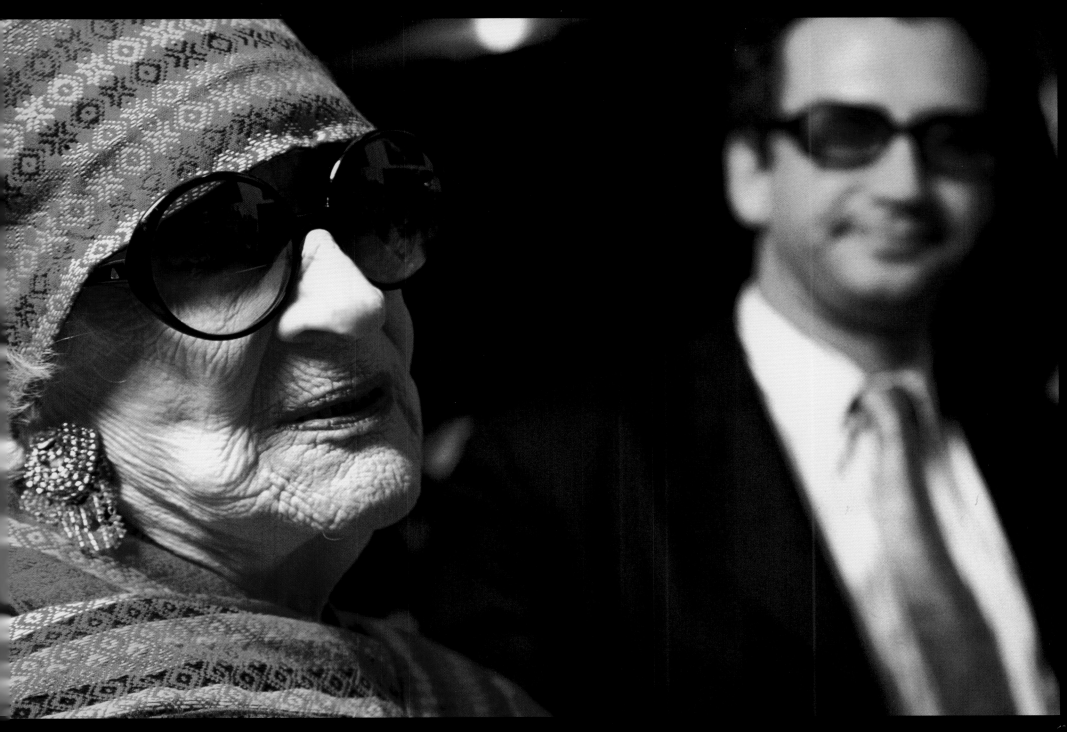

To dream of

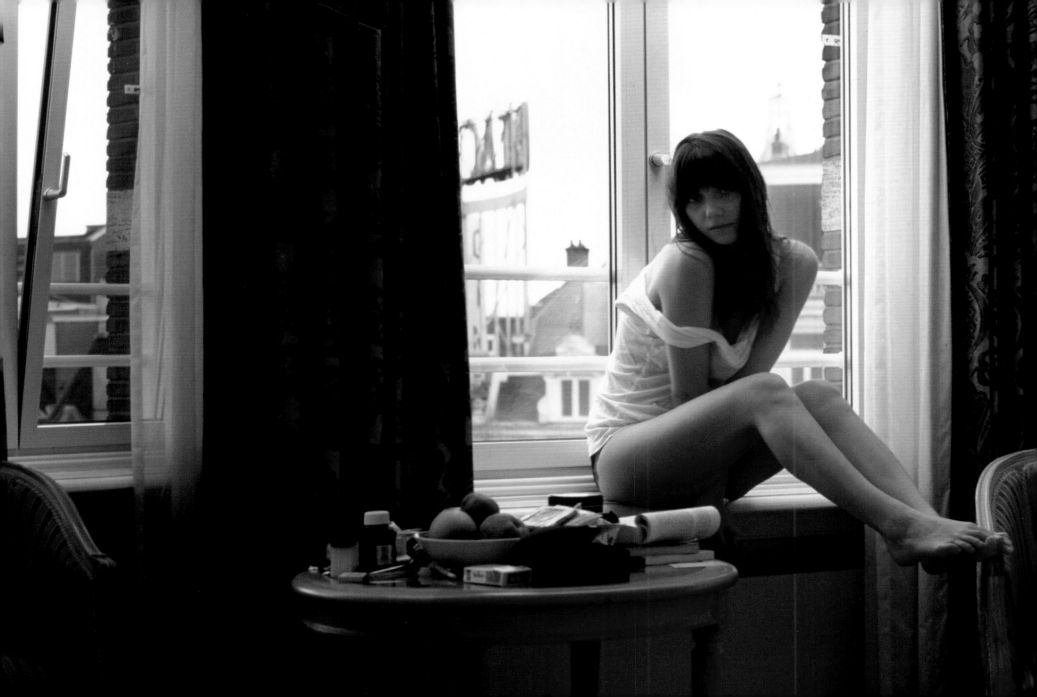

even in pain there is beauty

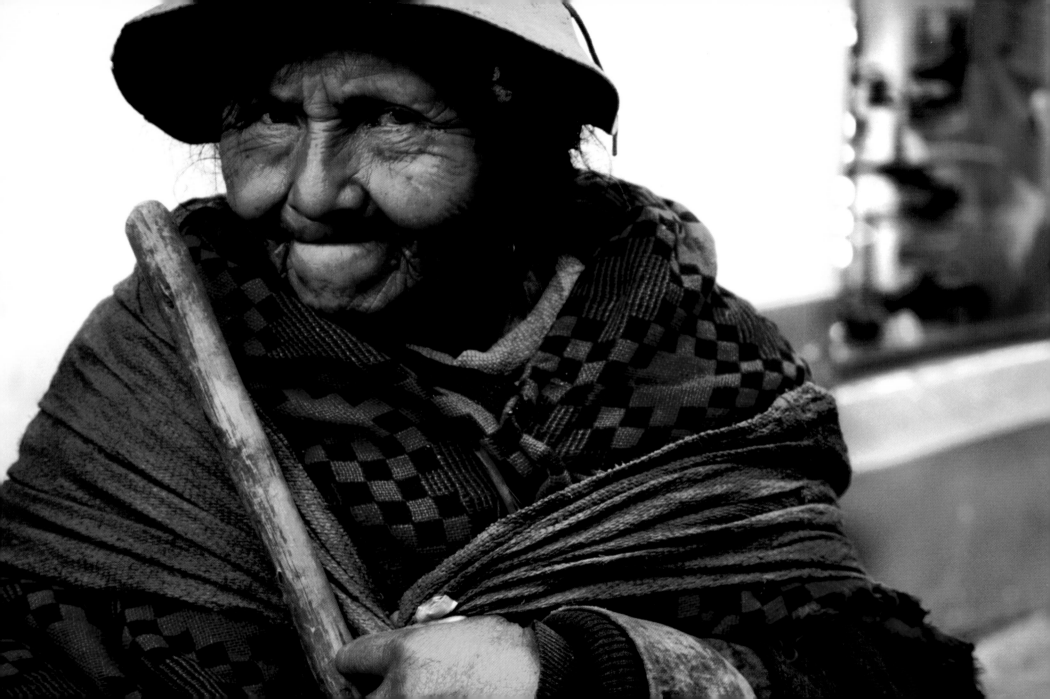

Think of a bull fight.

There really is something deeply unsettling in the intended
congregation of spectators for the purpose of eagerly watching
an unnatural death.

And yet, if I were a bull, I sure would rather go fighting.

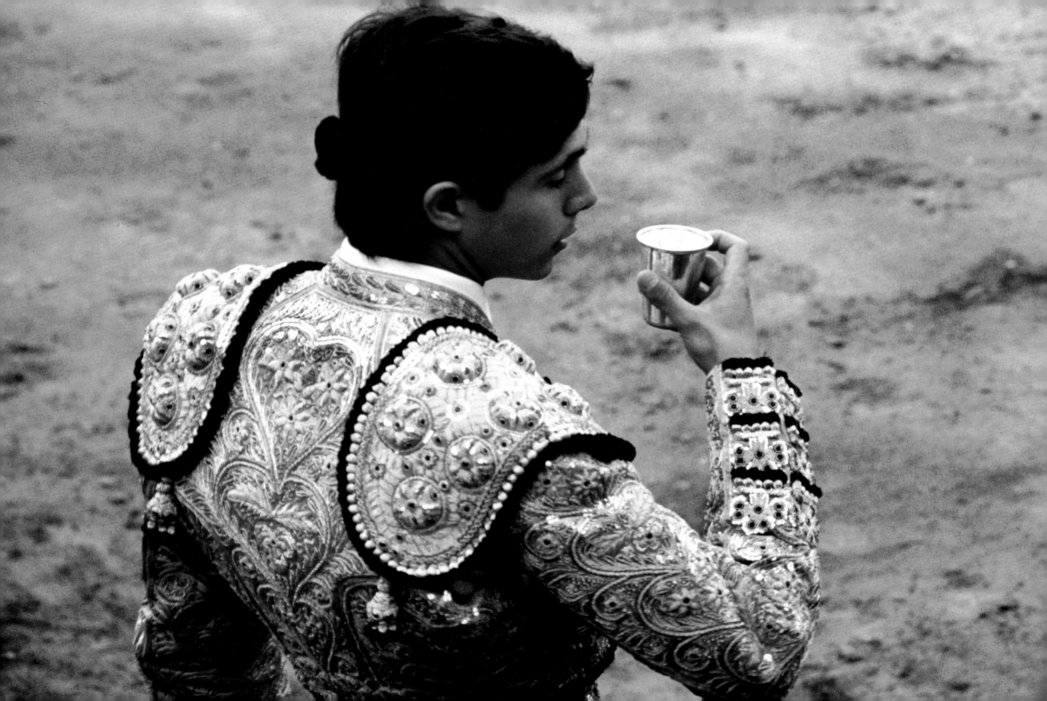

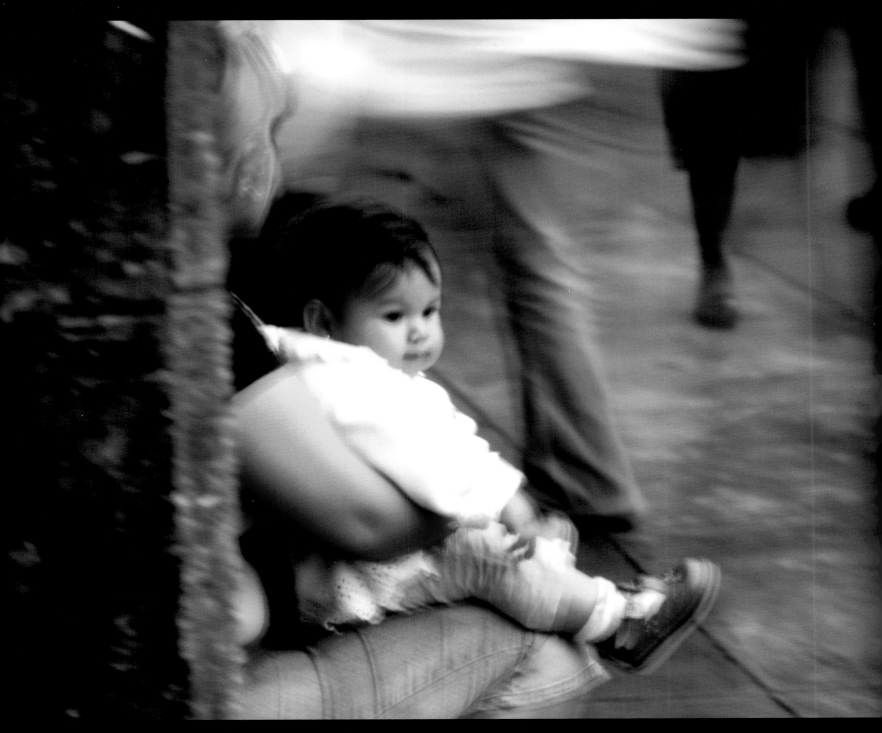

VENTURE

## VENTURE

Originally, we all have a free inner beast; a unique, powerful, primal passion
for something.
Anything.

In a world saturated with societal norms of conduct, even the rebel has
been given a mold to fit in. Initially, these norms are a wonderful system
responsible for catapulting humanity into a state where we no longer kill each
other at random will. Where we all know how to be courteous, civil, polite to
each other.

Yet when those norms come to shape the internal core of our personal "self",
we have a problem. There is only so much freedom we can have when our indi-
vidual character is fashioned by ideas and concepts that are not our own;
Independent ideals greater than ourselves that we 'ought' to follow.

Beyond the basic rule of law, conformity can be a wretched form of spiritual
death, vanquishing freedom so efficiently it can be difficult to recognize when
we see it. To be exact, freedom is not found in mass-produced dissent: goth,

punk, or any other form of organized rebellion, is as corrosive as the system it rises against. Fake is a malignant condition. Yet against all odds, some people still march to their own drumbeat. We find them strangely confident in their own eccentricities and often wonder where they found the nerve to be so...unusual.

They seem to know something most of us lost.

I shoot life. As free and shameless as I can find it.

The following series is not intended to evoke in you the same feelings and meaning I experienced when I shot them.

I trust you will find your own.

But they beg a question, one I believe each of us needs to ask—

what keeps me free?

Think of Dolphins.

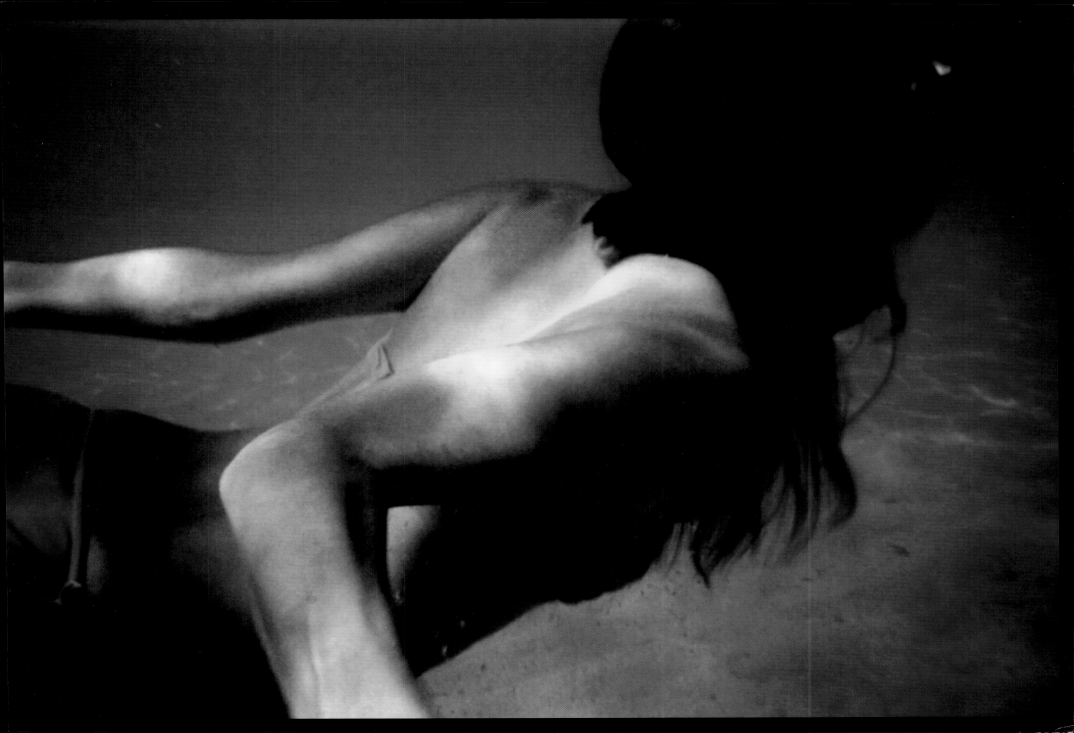

intelligent as us, yet their surroundings fit

eed to change and develop and construct and
rthing around them because the world suits them
s.

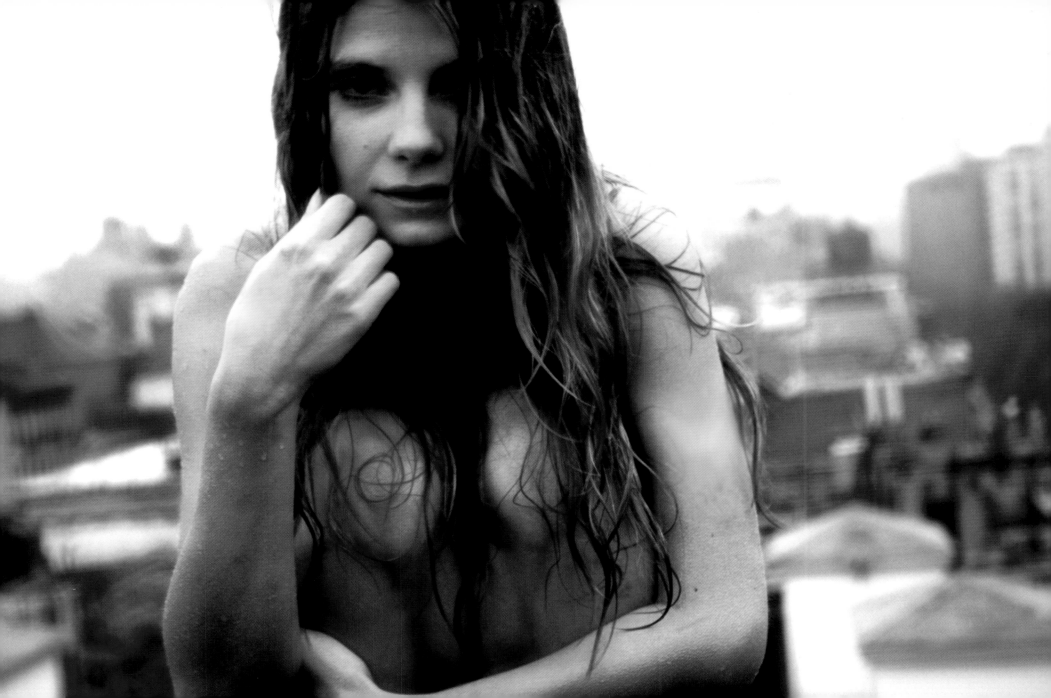

They do not need to build spaceships.

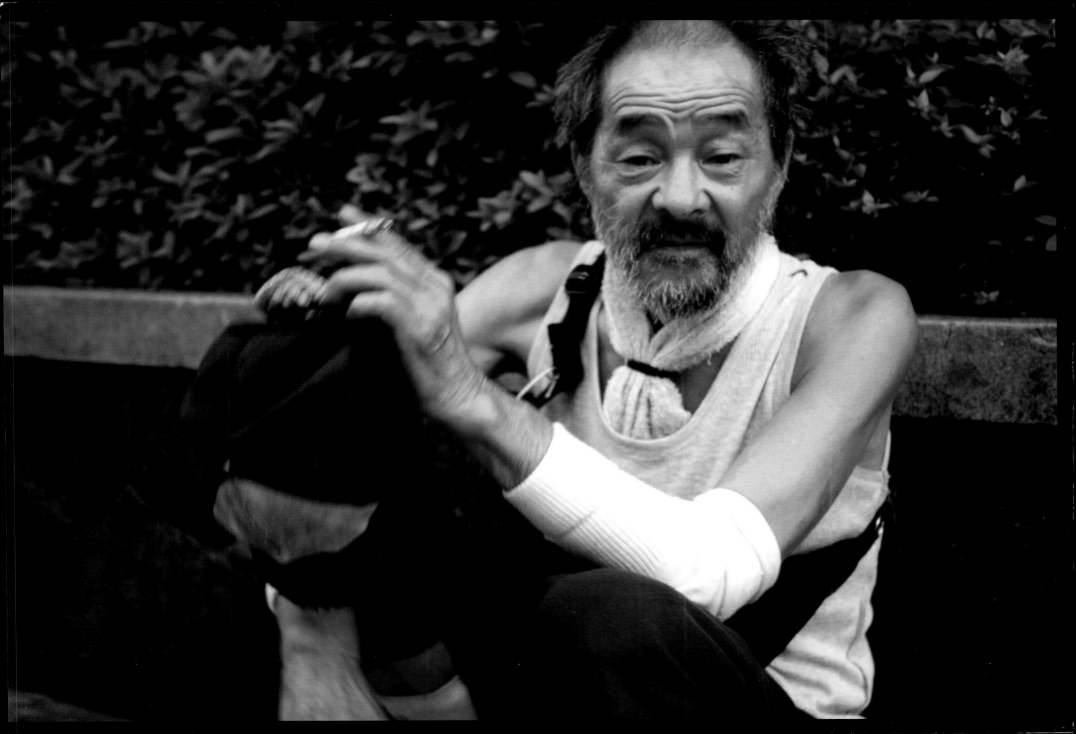

s staying together, eating, and playing.

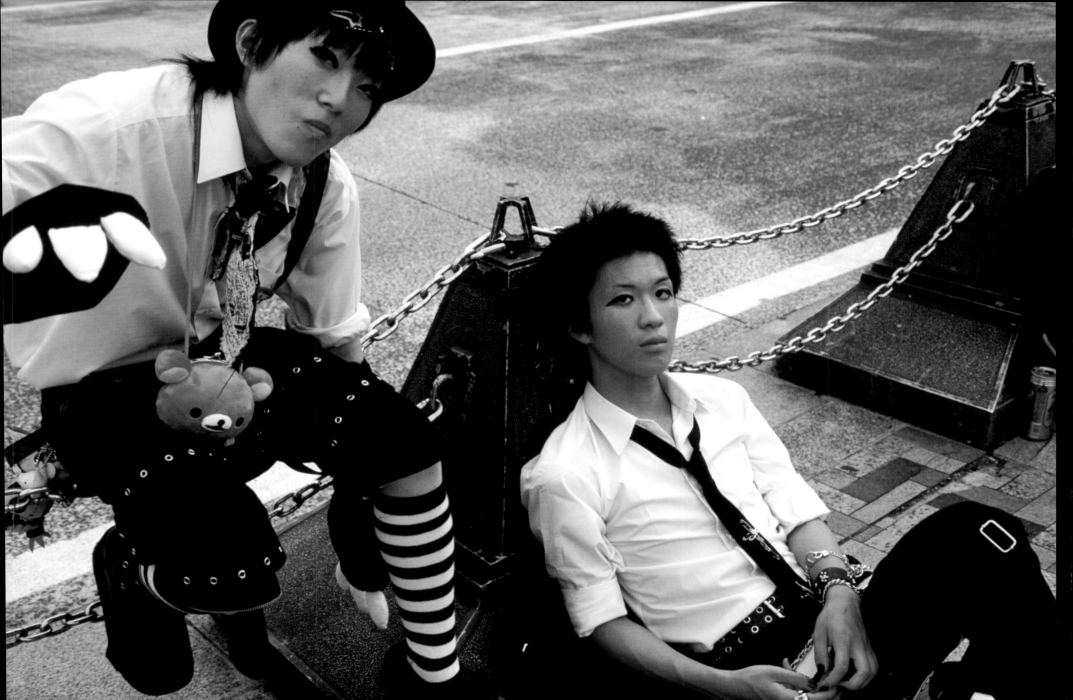

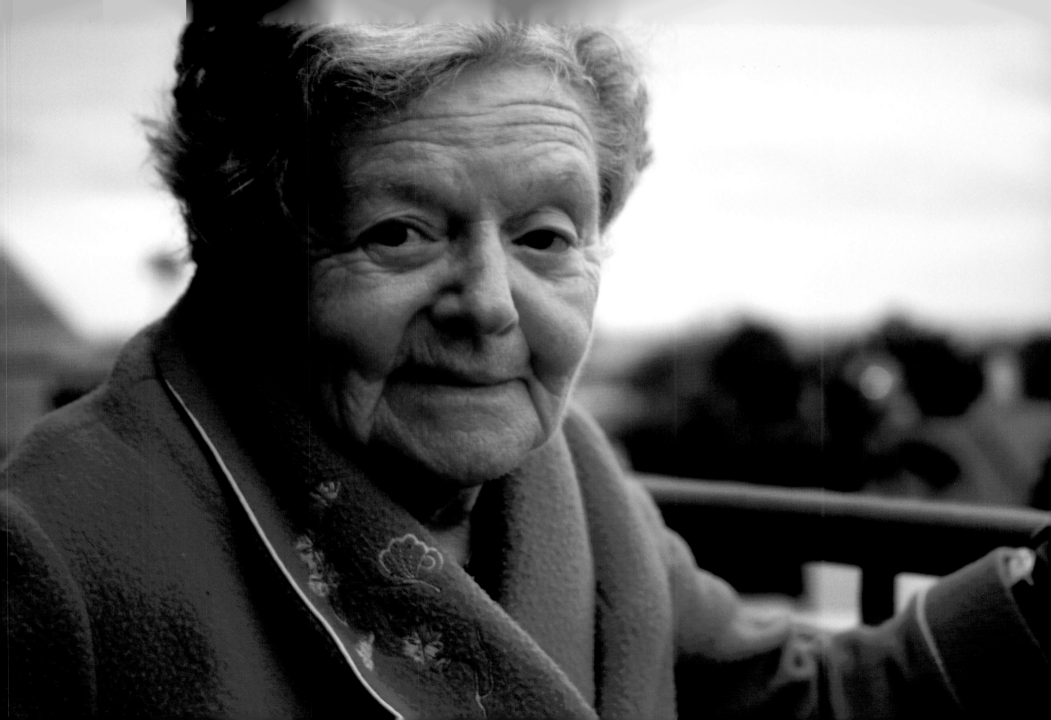

And then look at us.

Emotional satisfaction lost for ego-bench-marking;

Because despite our fancy concepts and lofty aspirations, all we
really want is to be warm and protected and happy.

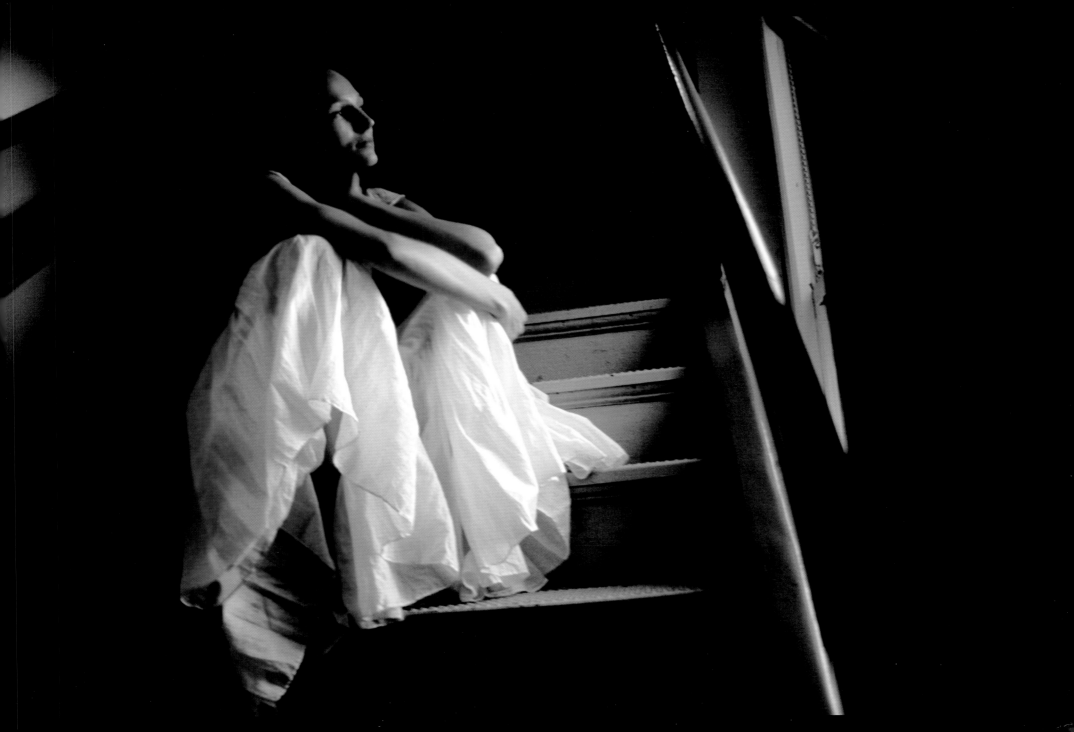

Unfortunately the simple, calm, pure-perception blissful life of
a dog—the life we had as babies—cannot be ours again.

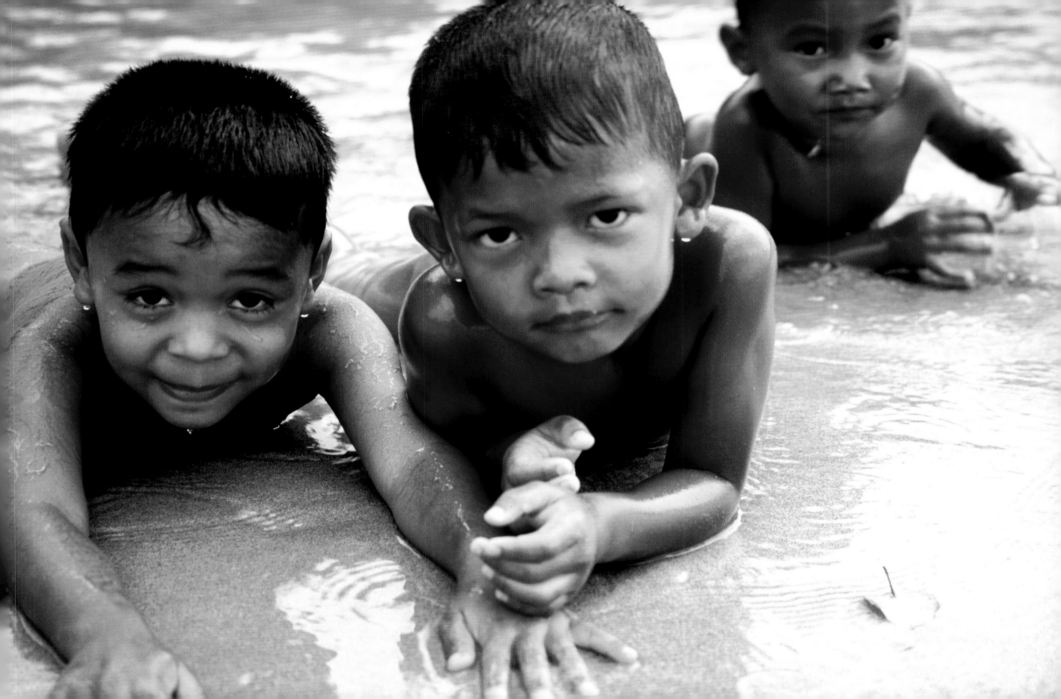

Since we began to speak, invented language, and filled our heads with words we use to define these concepts we follow with unquestioned determination.

Some words are obviously better to follow than others.

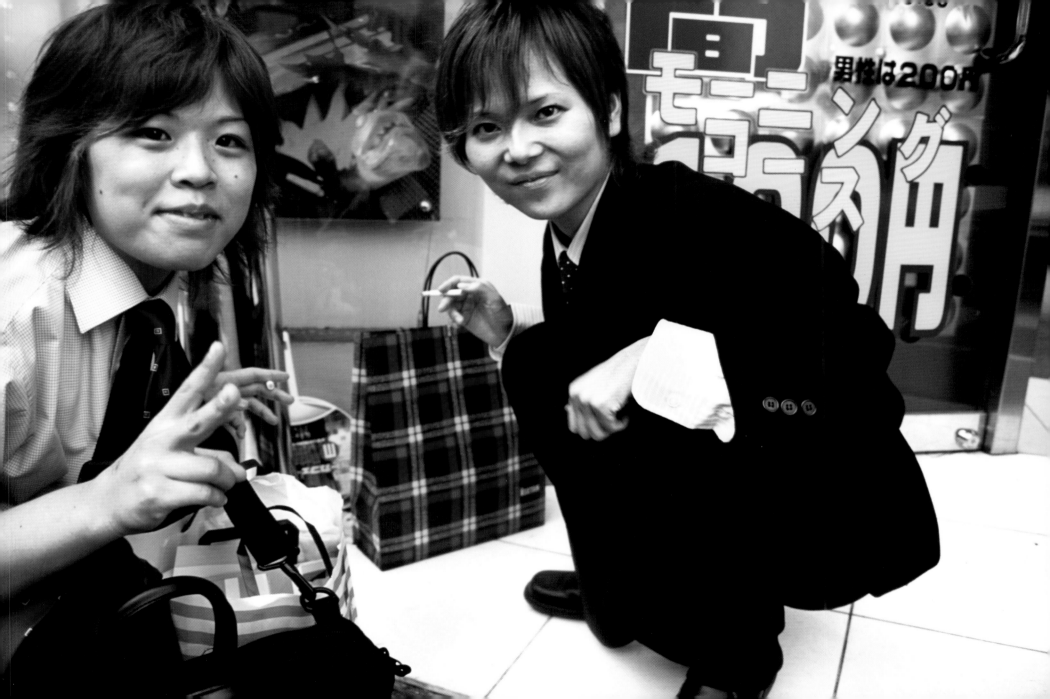

Yet even in the face of strict oppression
and loss of self, the human spirit persists.

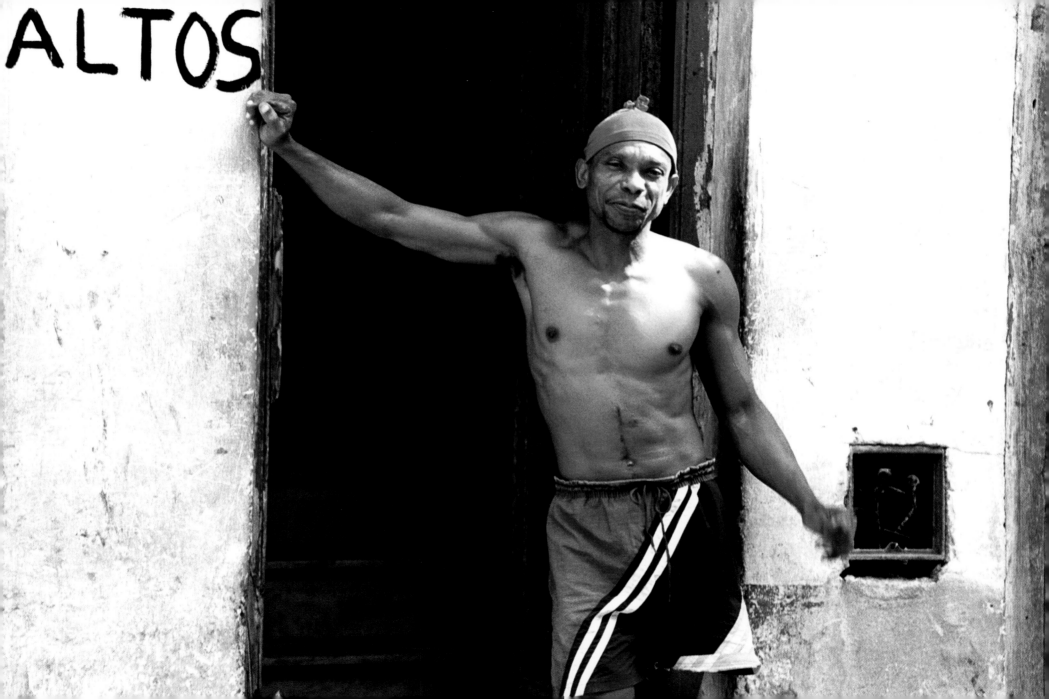

Freedom sets us in motion

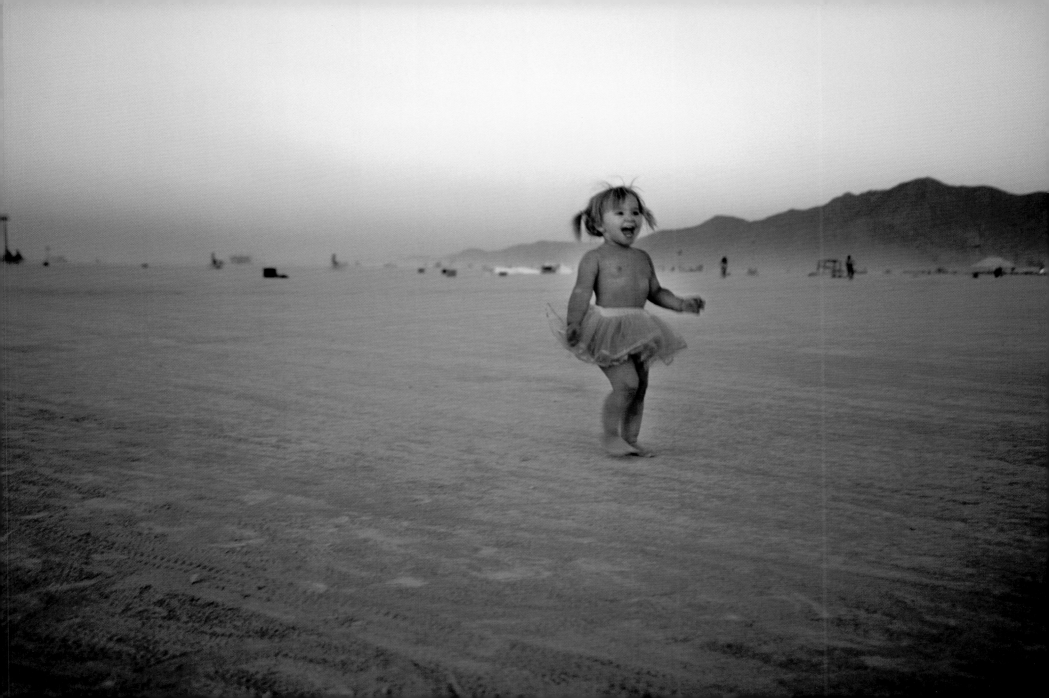

Allows us to choose our path

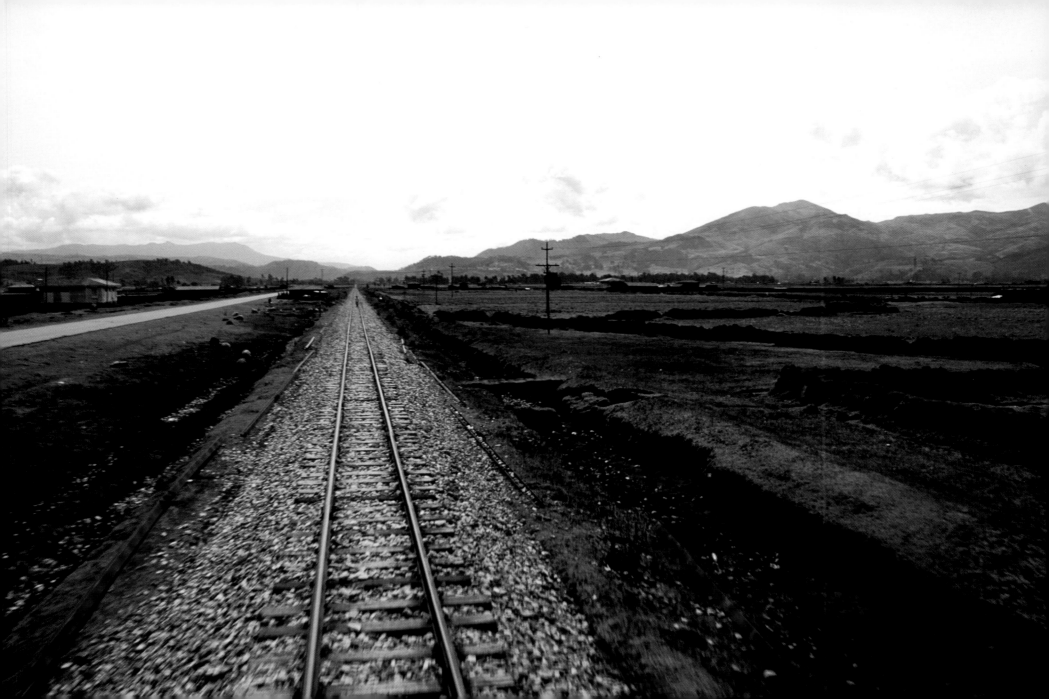

Or lose it.
Which is utterly relative.

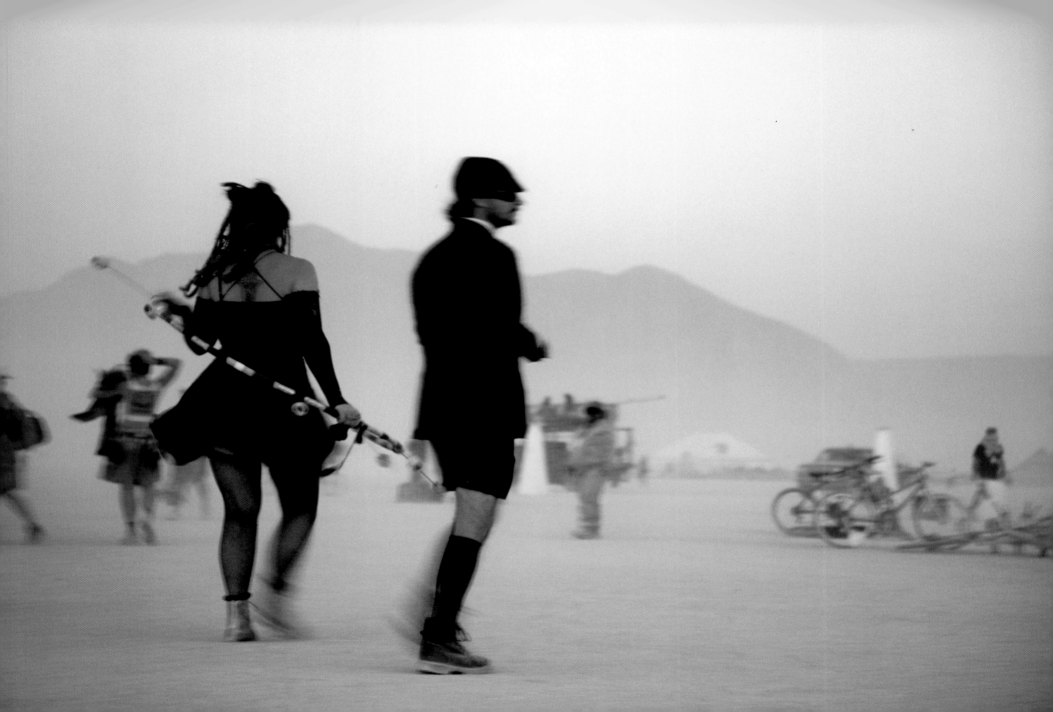

It is very difficult to go back to numb conformity after we see how society, which rose from needs, ends up shaping the wants that determine our lives.

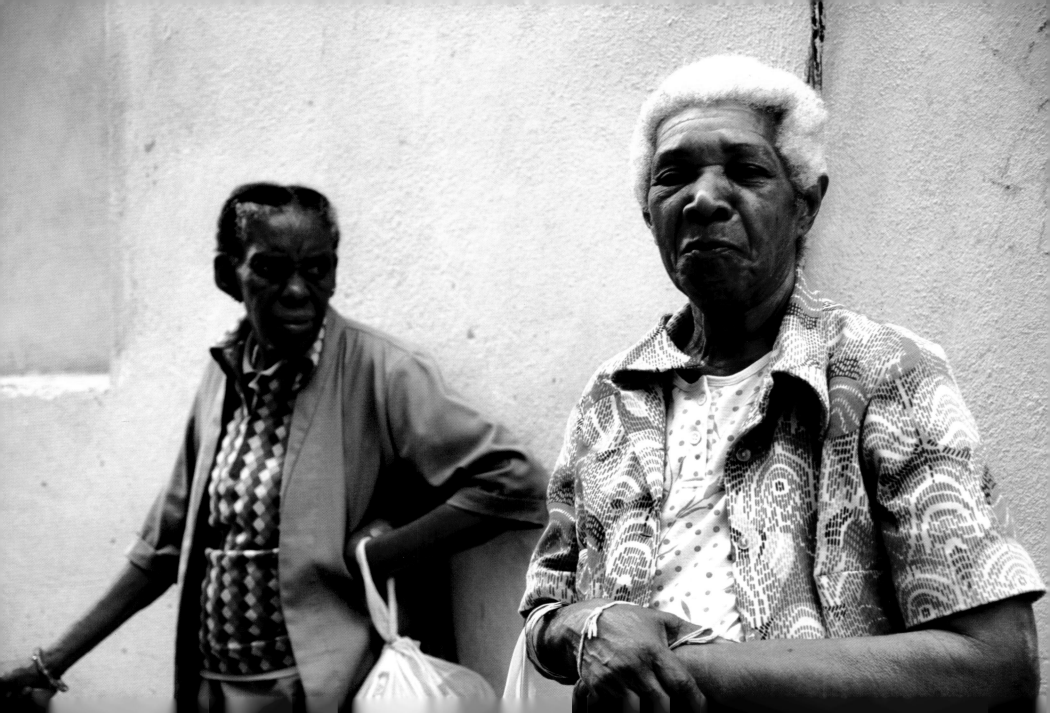

A funny thing happens when we begin to take
food and shelter for granted—

"happiness" becomes a real problem.

Then we need something to give us meaning, or satisfaction, or distraction; so
we invent ideals for meaning, challenges for satisfaction, and entertainment for
distraction;

In the process often avoiding the so-elusive now.

Not all of these "activities" make us happy.

Love makes sense.
[As much as it seems it doesn't]

In some cultures just having food and shelter means you are happy.

Staying content when necessities are met is harder than most people think. Since needing something makes you want it, wanting something breeds a drive. And life can get pretty strange without wants and drives.

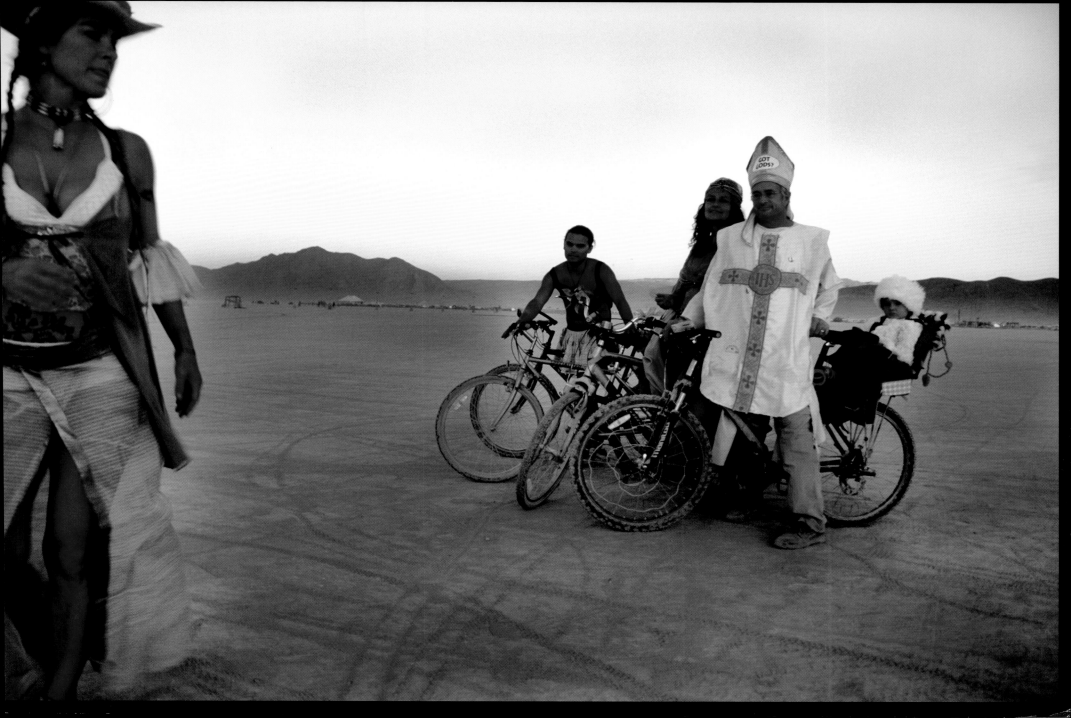

Then there's always individual expression

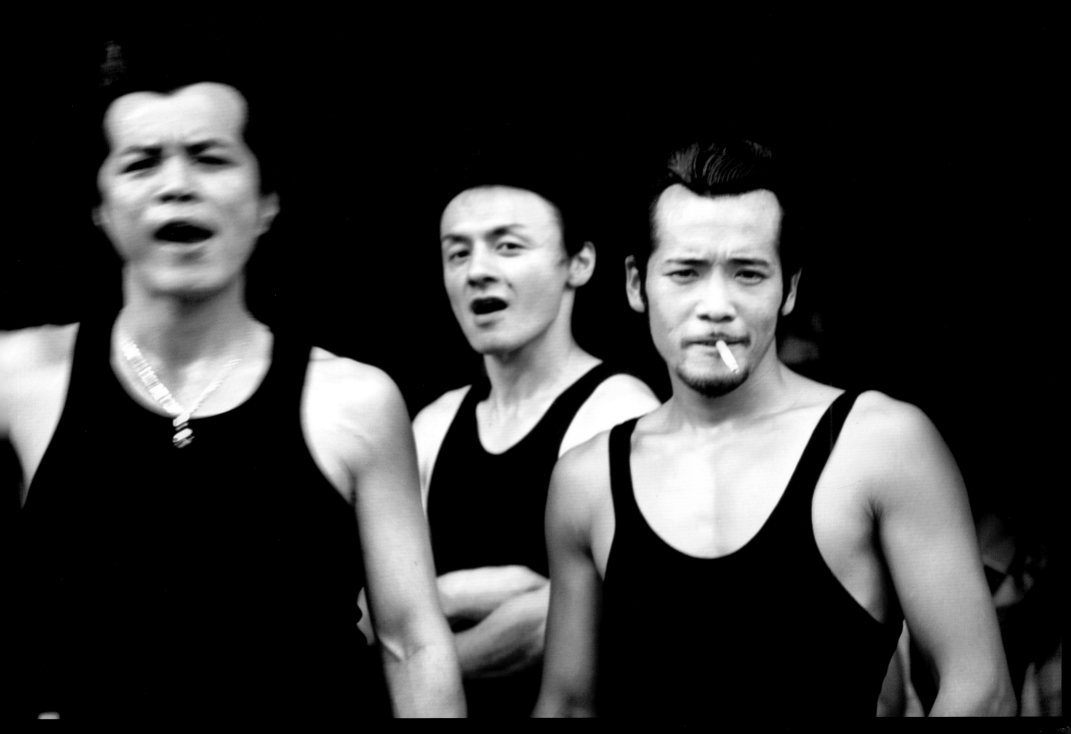

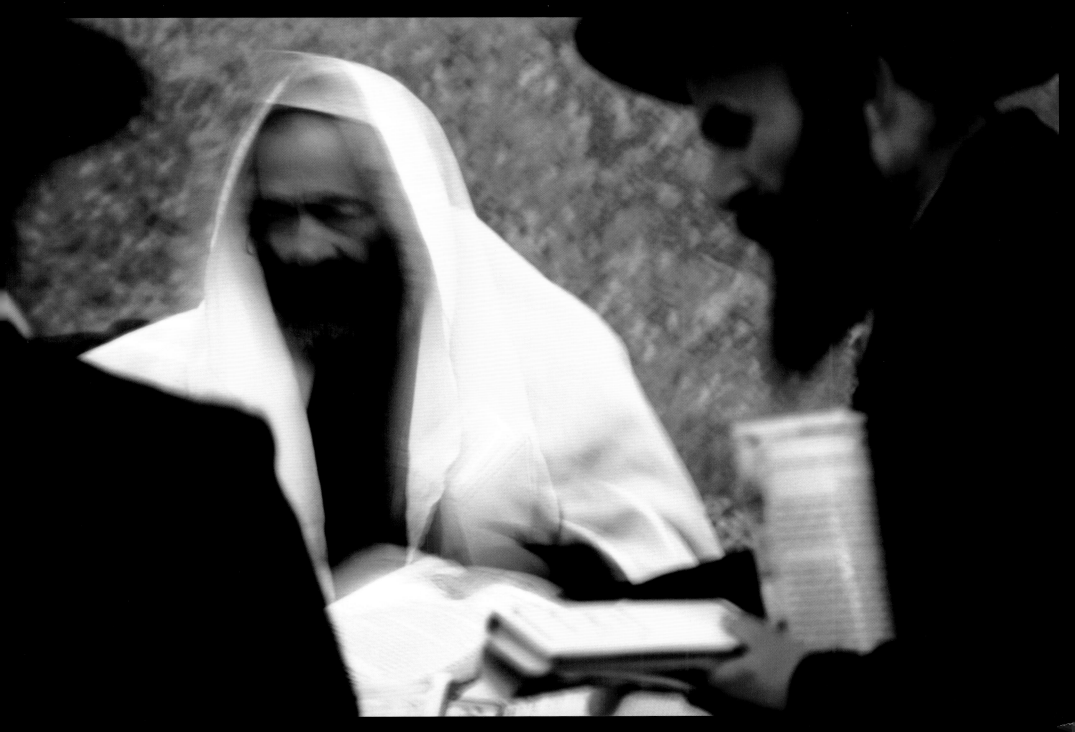

Or honest introspection.

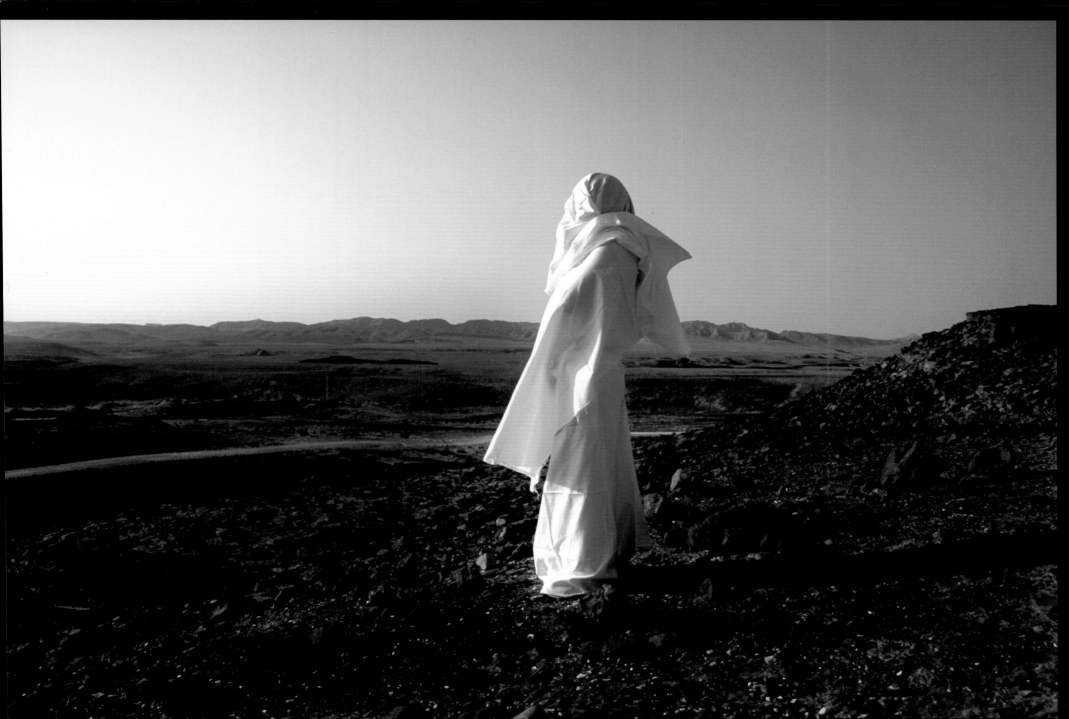

In countering culture, in demolishing drives and wants without
upholding others—you end up with a certain dose of emptiness.

So pick one.

Maybe the closest to dolphins are monks

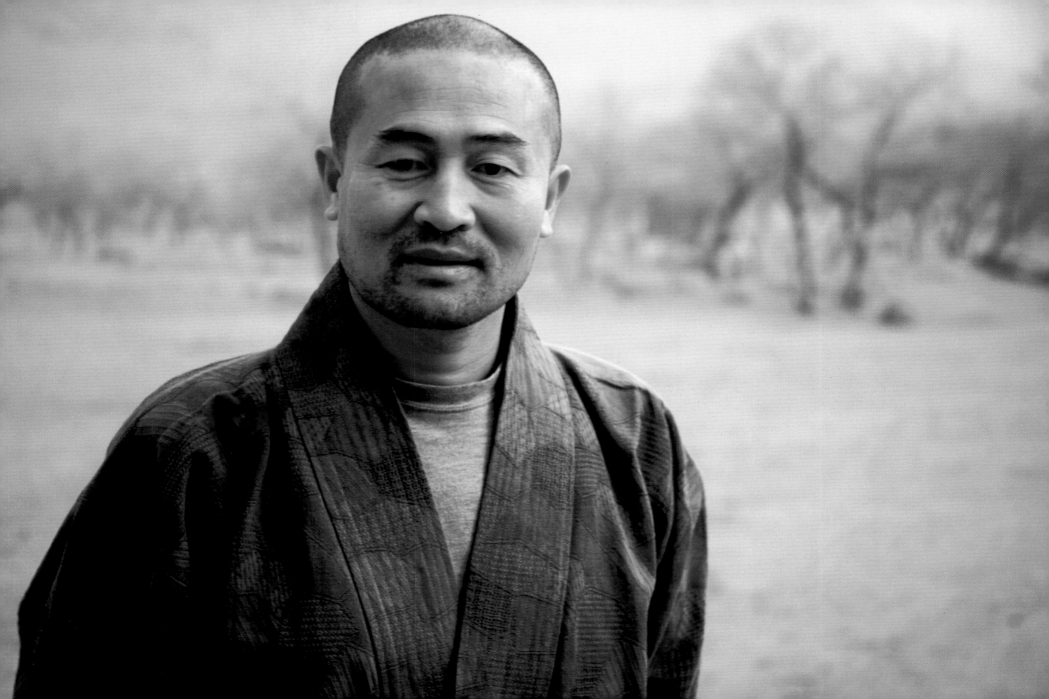

or burners

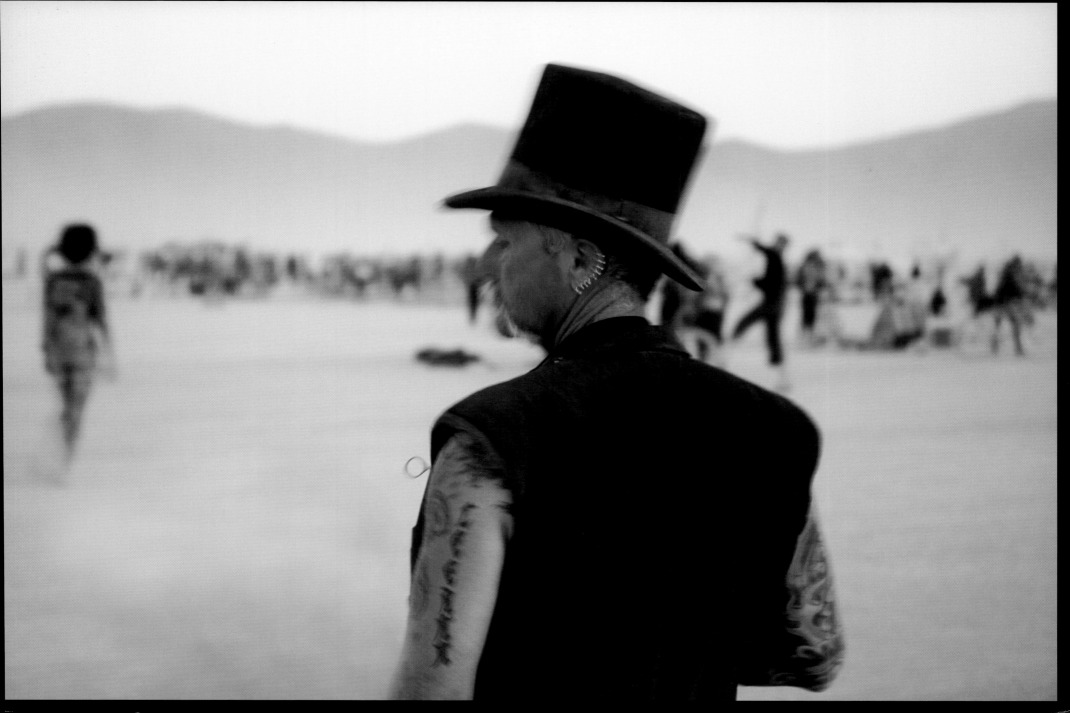

or children

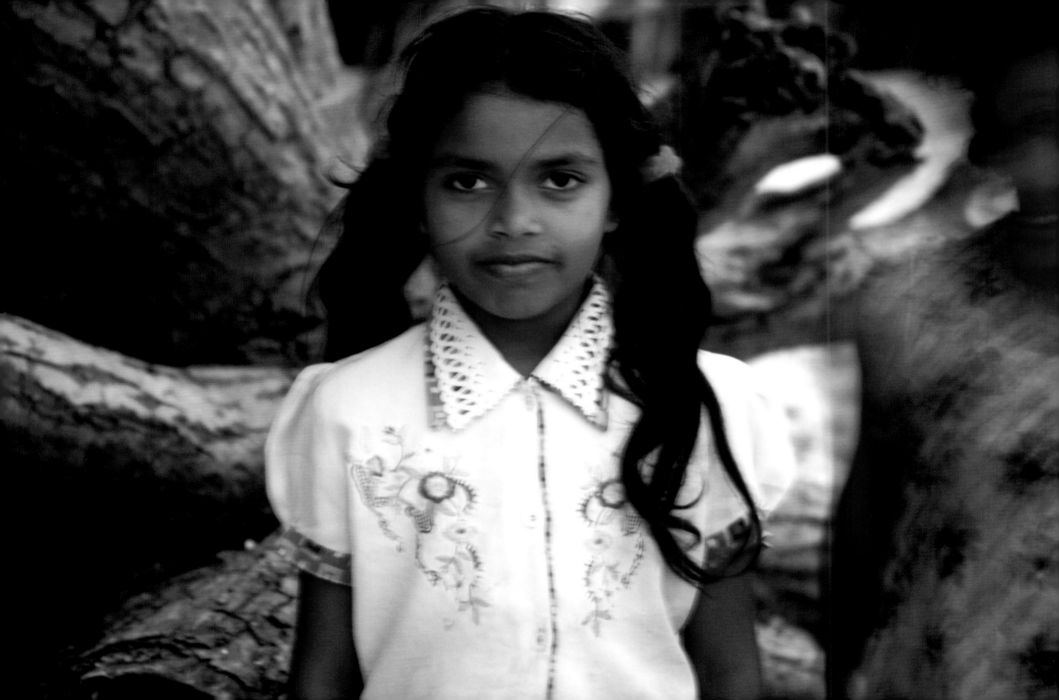

And yet culture feels so...natural.

So innate and unavoidable that we tend to take it for granted,
as life's only possible frame of reference.

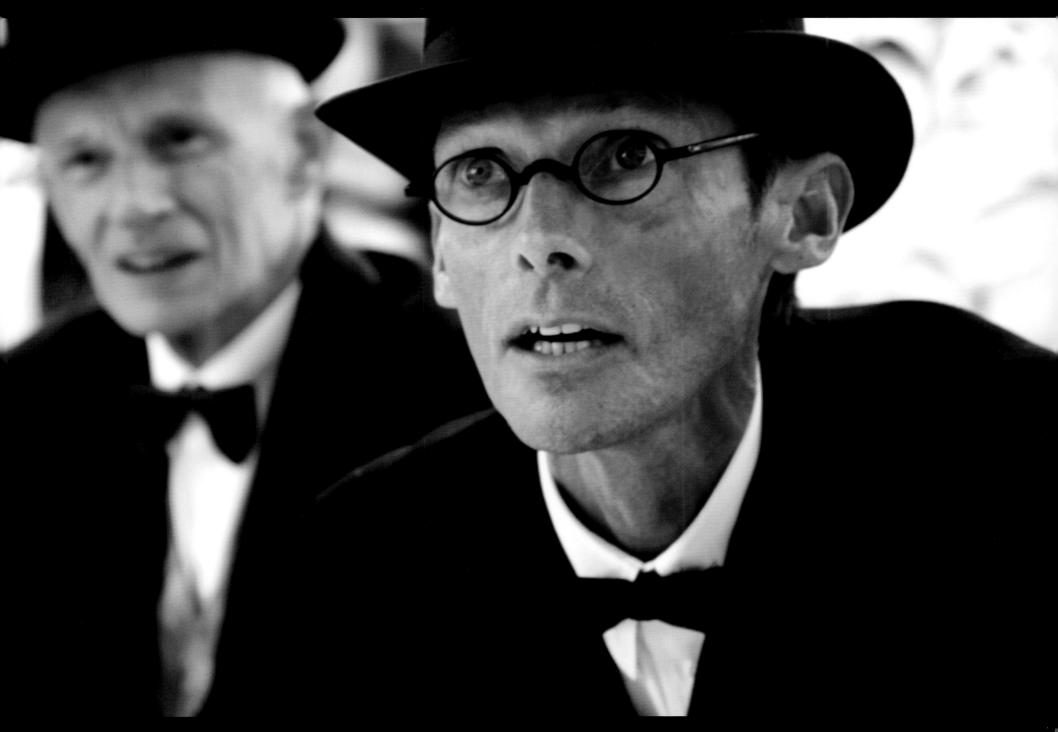

until you question it.

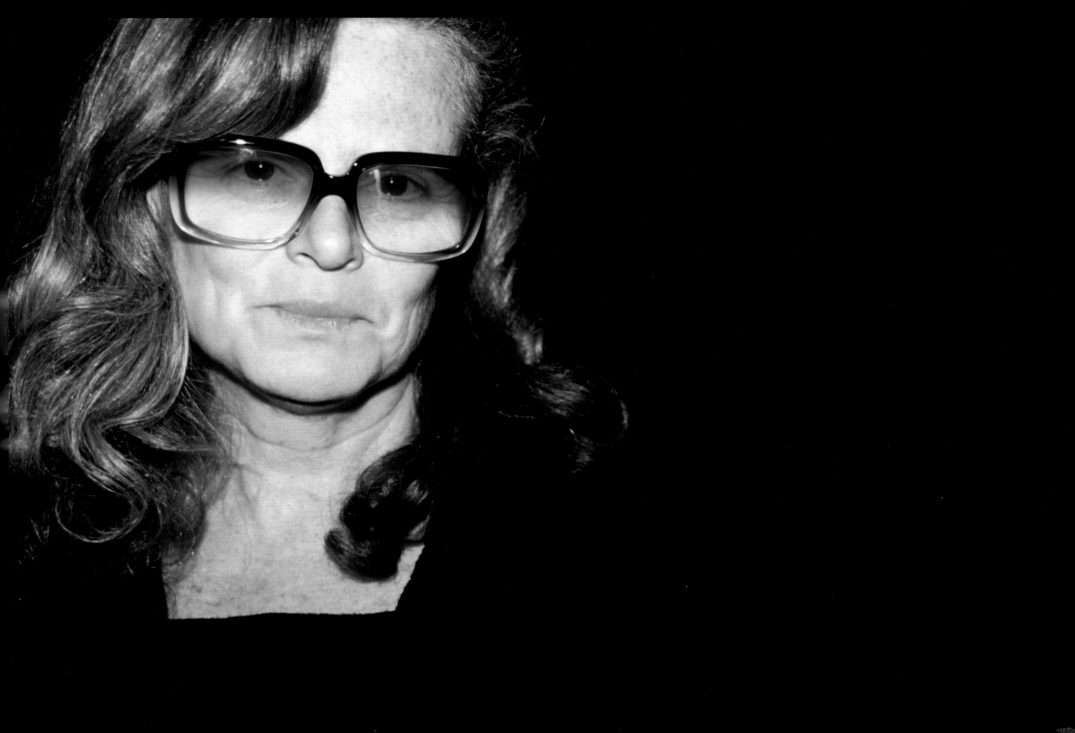

avoid it

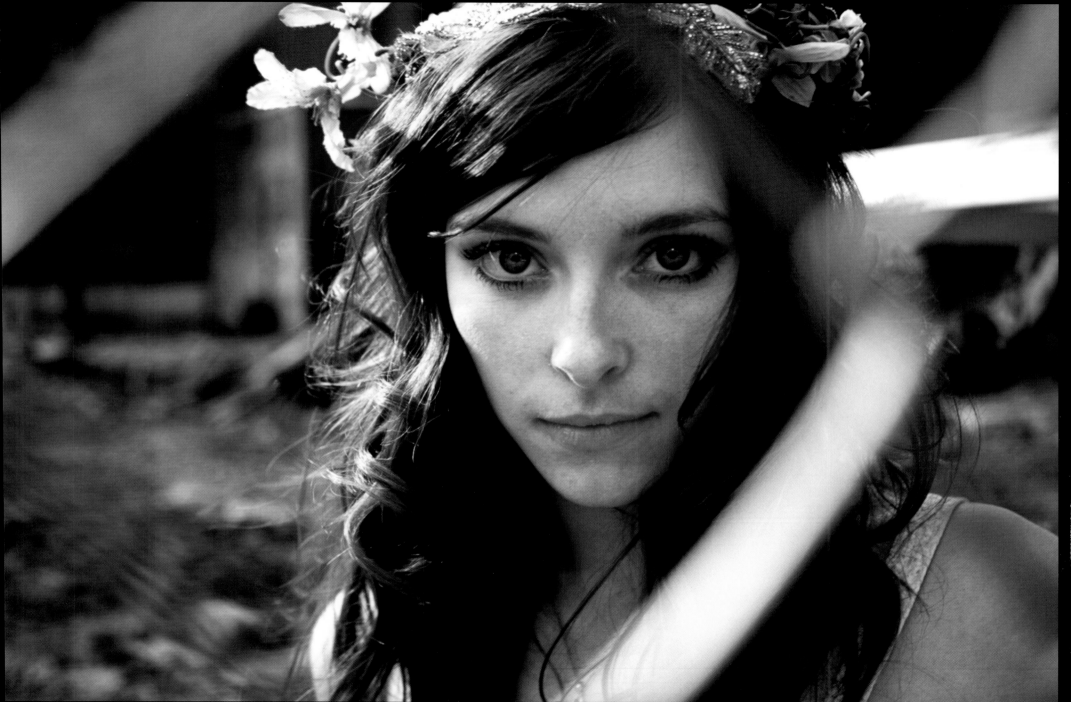

escape it

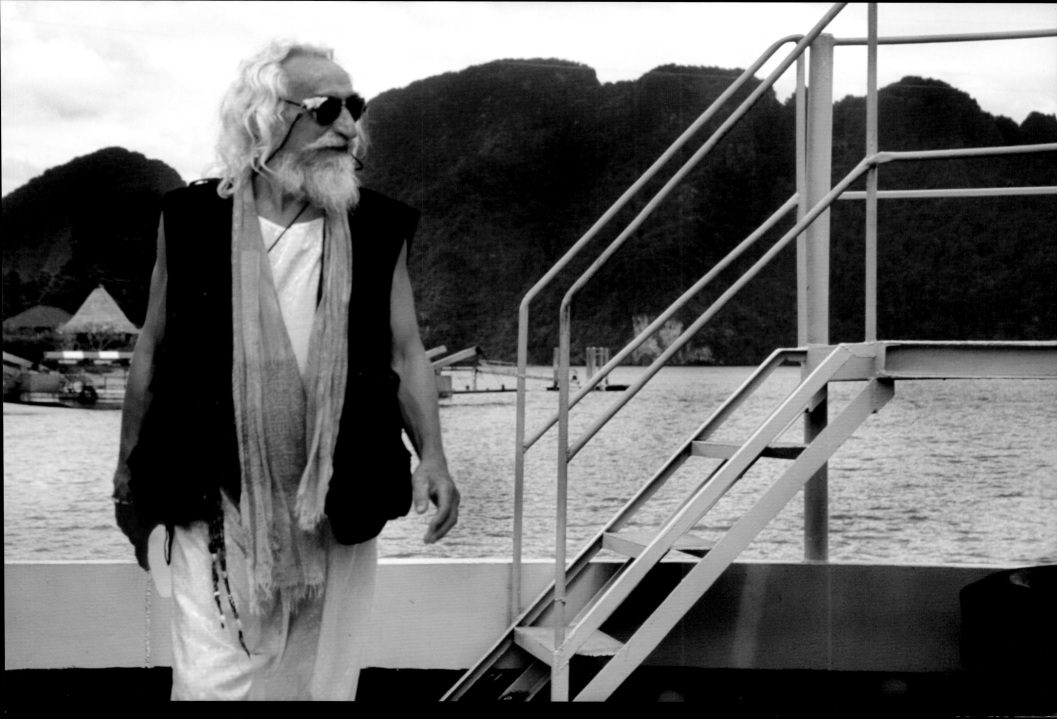

or breakout altogether

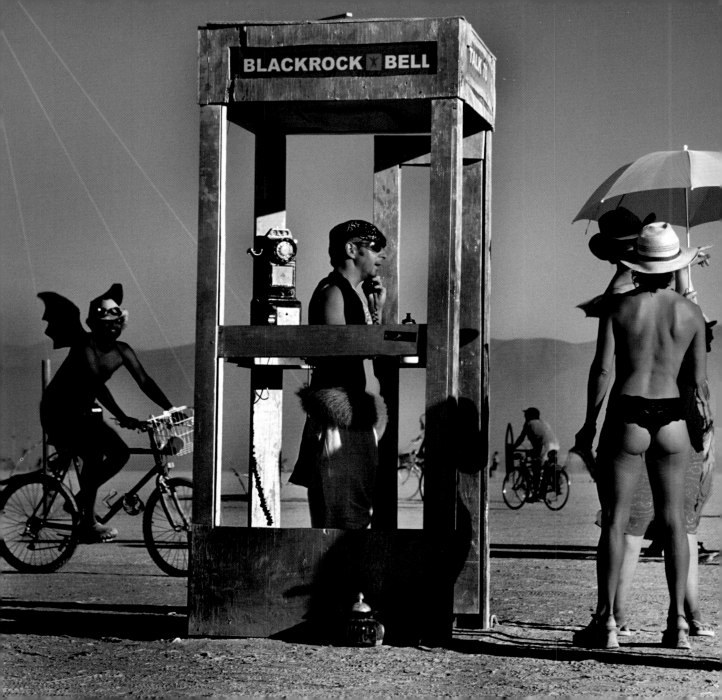

THEORY of WANTS

THEORY of WANTS

At any given moment, six billion universes independently coexist.

The first time we take our head out of the sand and notice that not everyone
thinks, feels, or sees the world just like us, can be terrifying—ideally
followed by a great sense of newfound relief:

If no one has it "right", how can any of us be "wrong"?

Though even in that vacuum of absolute truth, where there is no one left but
us to say what matters, some ideas still make more sense than others.

Society is the earliest frame of reference: what we learned we "ought" to do,
before we knew that what we "ought" to do was being taught.

Yet society needs a driving force. While our social contracts aspire to
guarantee freedom, the imminent question slowly becomes, freedom to...?
To wake up in the morning safe, sheltered, and fed, and do or be what?

Wants fuel society.

Wants evolved from the need to eat to the drive to keep your loved ones safe;
and then at some point the guiding necessity gave way to a crazed drive to
rule, be rich, successful, distinguished, famous, what ever makes you happy;
now happy is where things can get tricky.

Once wants stop being necessary, altruistic, or unquestionable, the integrity
of the fabric of modern society is called into question.

If we can keep our priorities straight, our egos in check, and work a little
on empathy, good things lie ahead.

If we could strip ourselves of all we know, all we take for granted and base
our reality on, then dress back with only what we really need,
we have a chance to advance.

Forget, just for a brief moment, all those ideals you promise
yourself to keep; those principles you take to be...you.

Remember that most of the people on the globe today, as did
our ancestors, live in a strange world without electricity,
cell phones, running water, career aspirations, Myspace,
Xanax or celebrities.

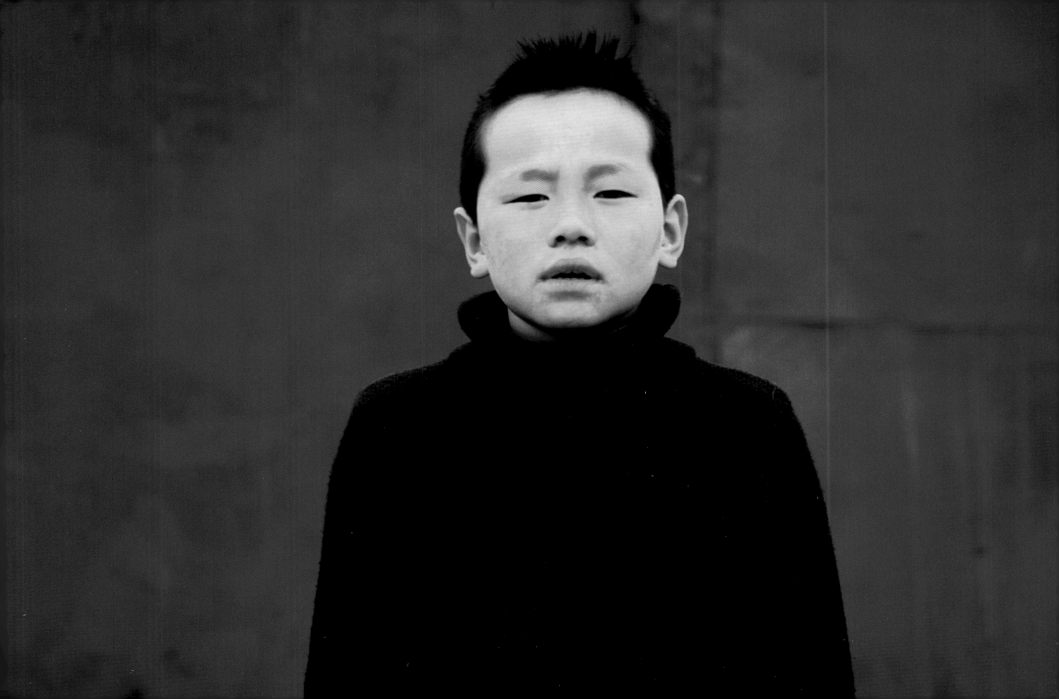

Now ask yourself what matters.

How do you call that strange feeling that grips us
when everything we came to take for granted stops
making absolute sense...?

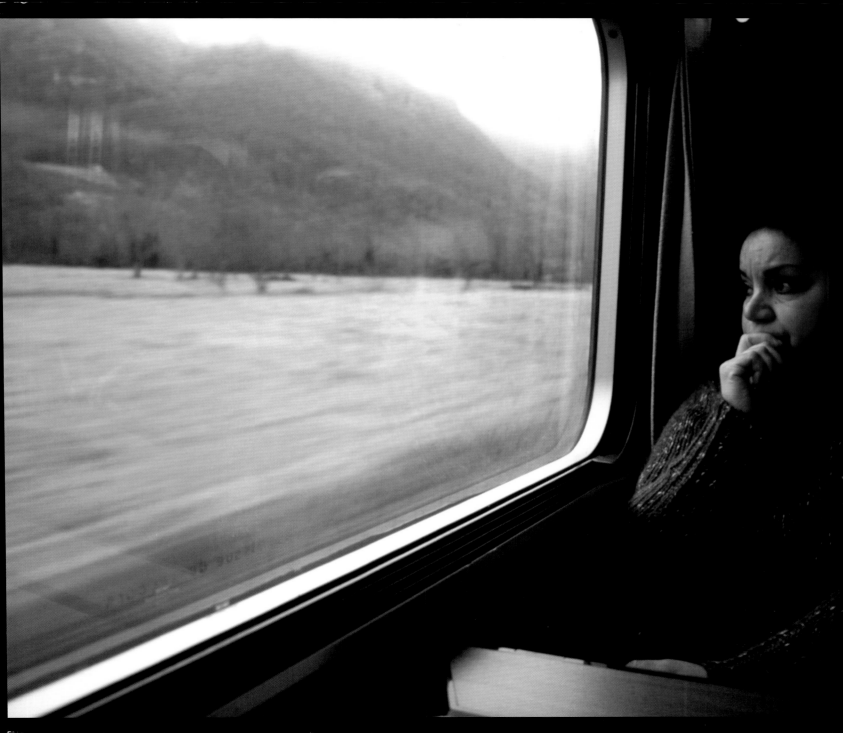

Some call it a crisis

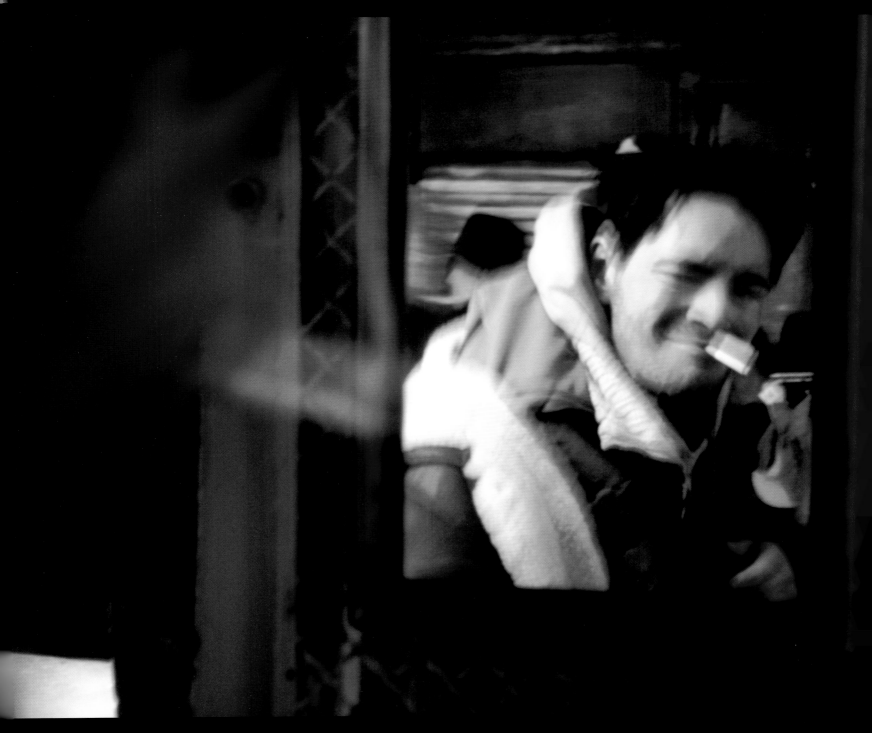

Some call it independence

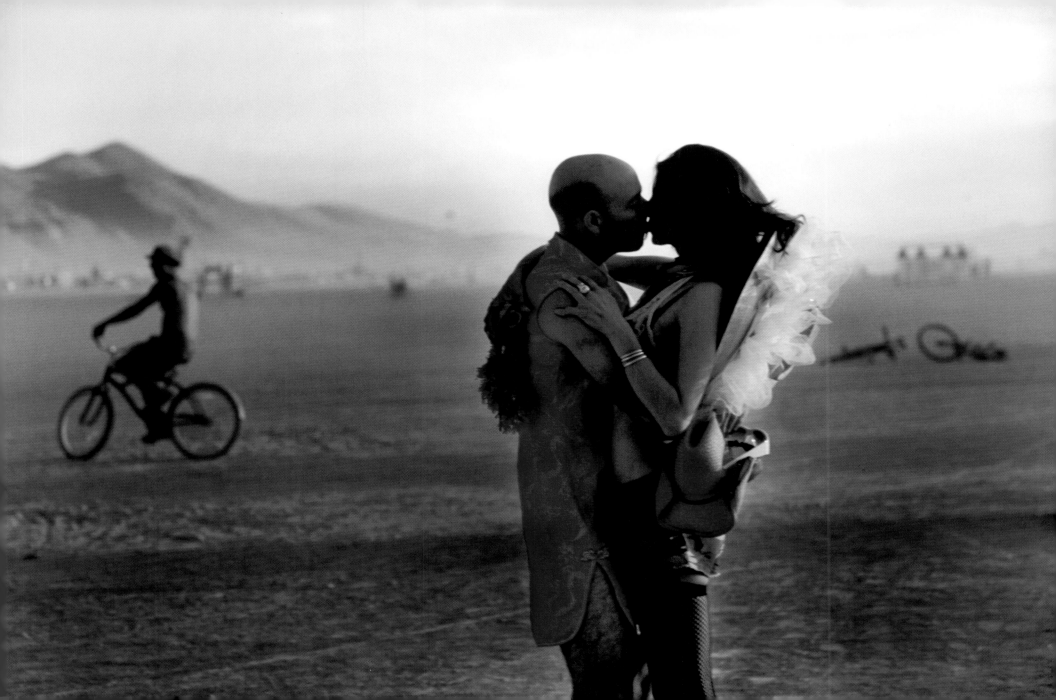

Some think you're crazy for driving yourself mad with these thoughts

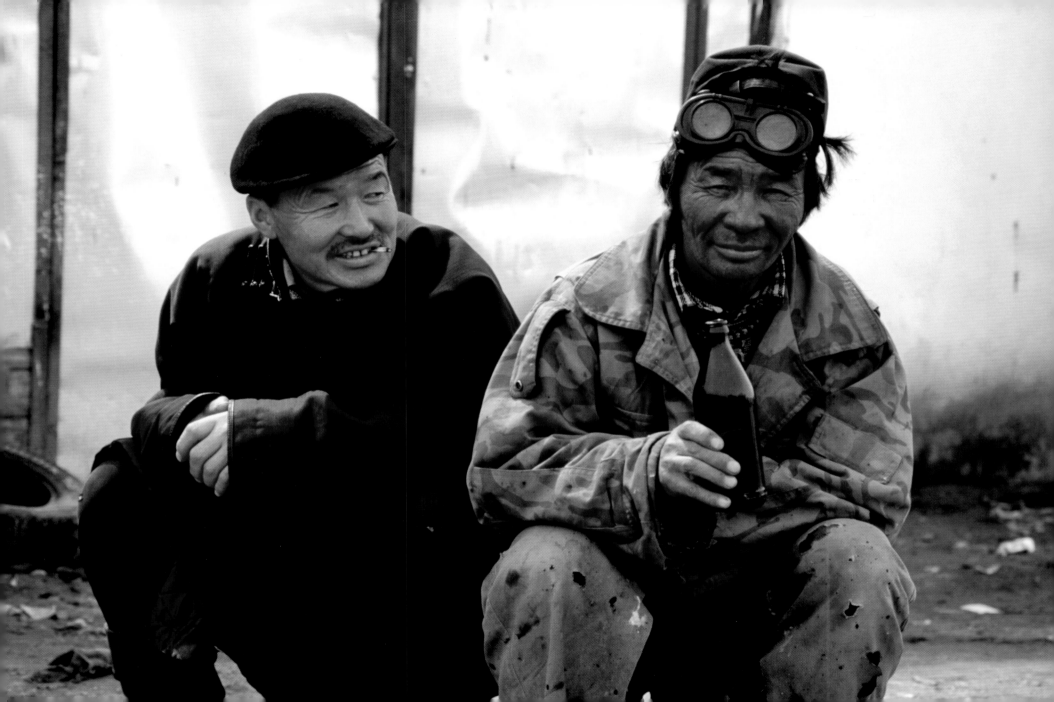

People in different places,

worry about different things.

And yet the common denominators

are greater than the differences.

Once you go off the grid and search for answers

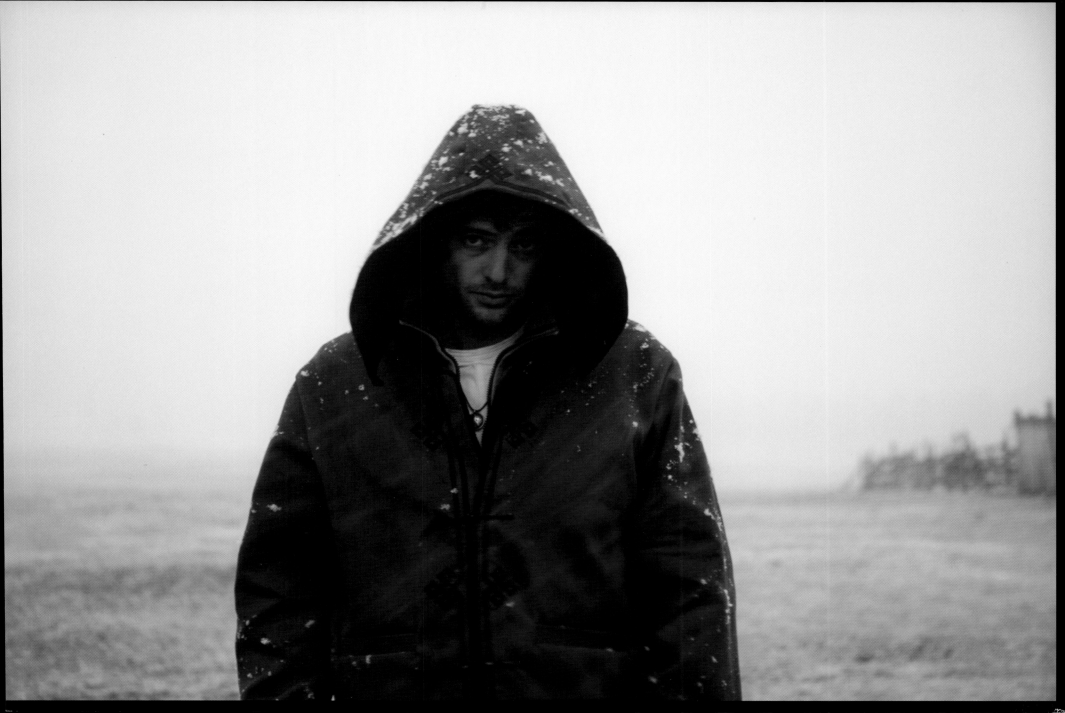

You will find remote villages where people have
different questions

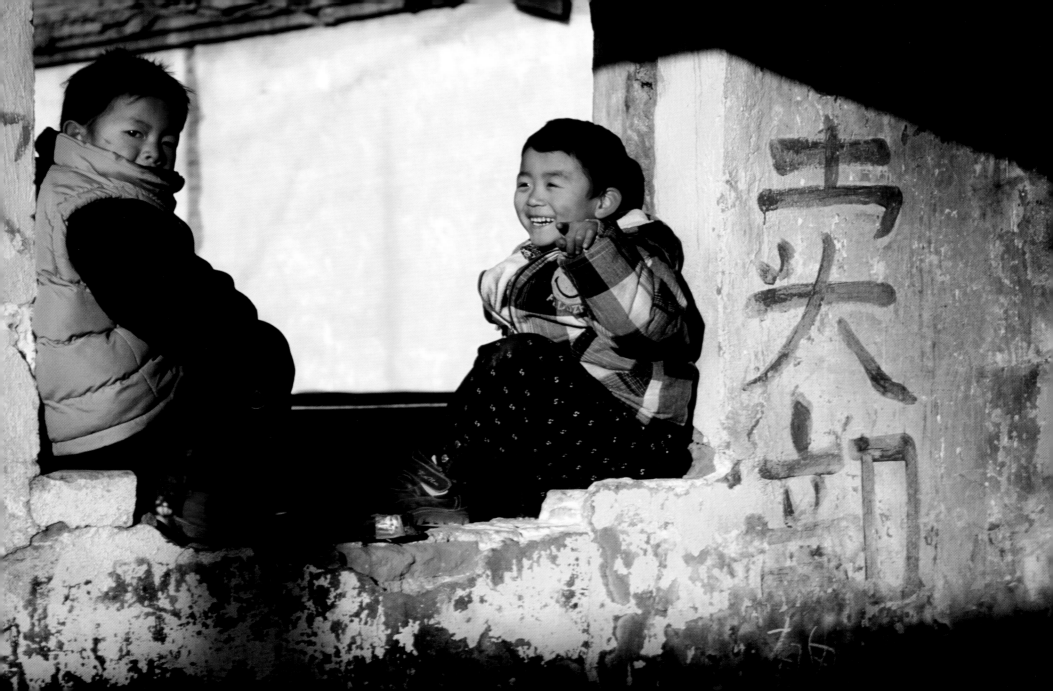

And bustling towns where the questions are so great
that trained professionals are paid by the hour
to find more questions.

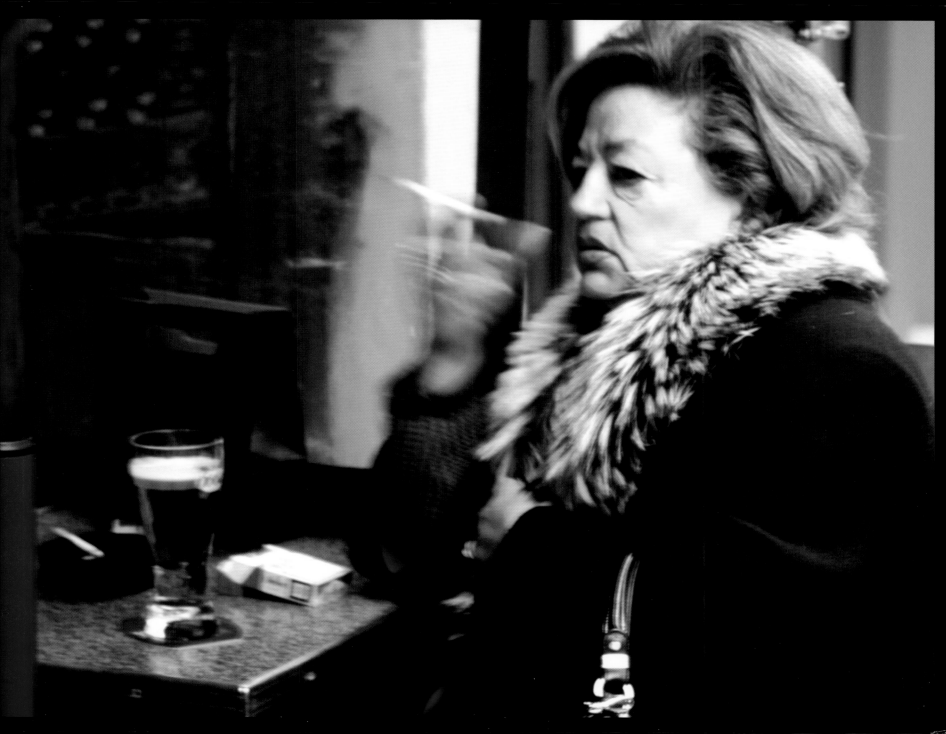

Until you find the original state.

Where we hunt because we're hungry, dress up because
we're cold, and are happy if we're fed and warm.

It all makes perfect sense.

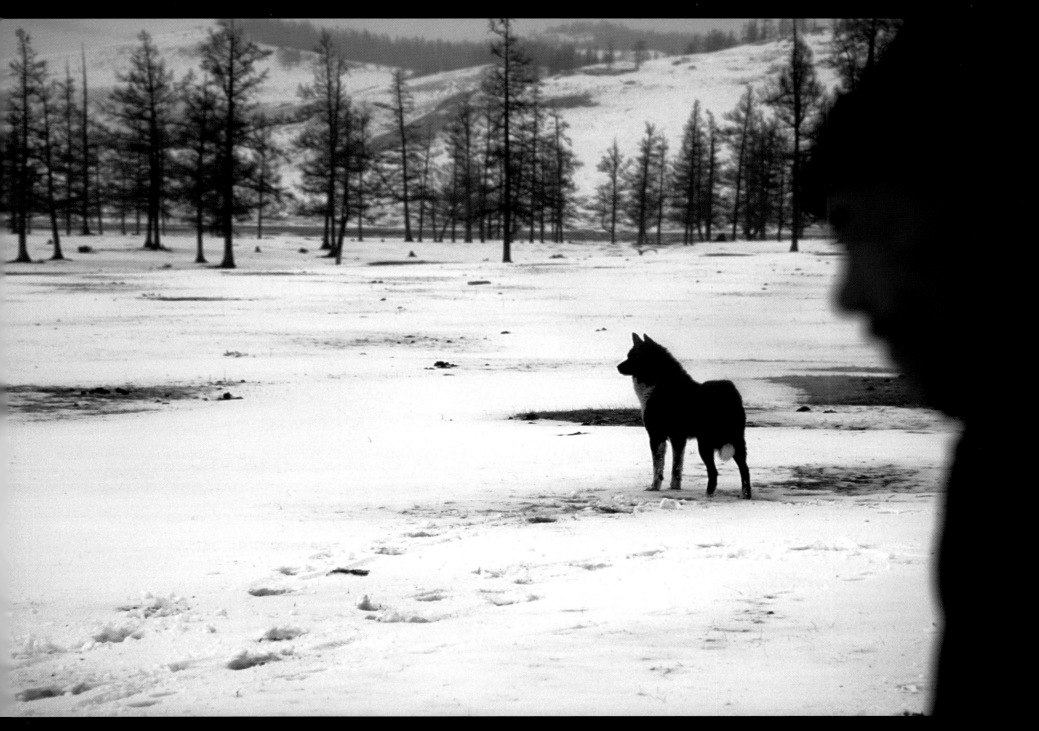

What a shame common sense ain't that common

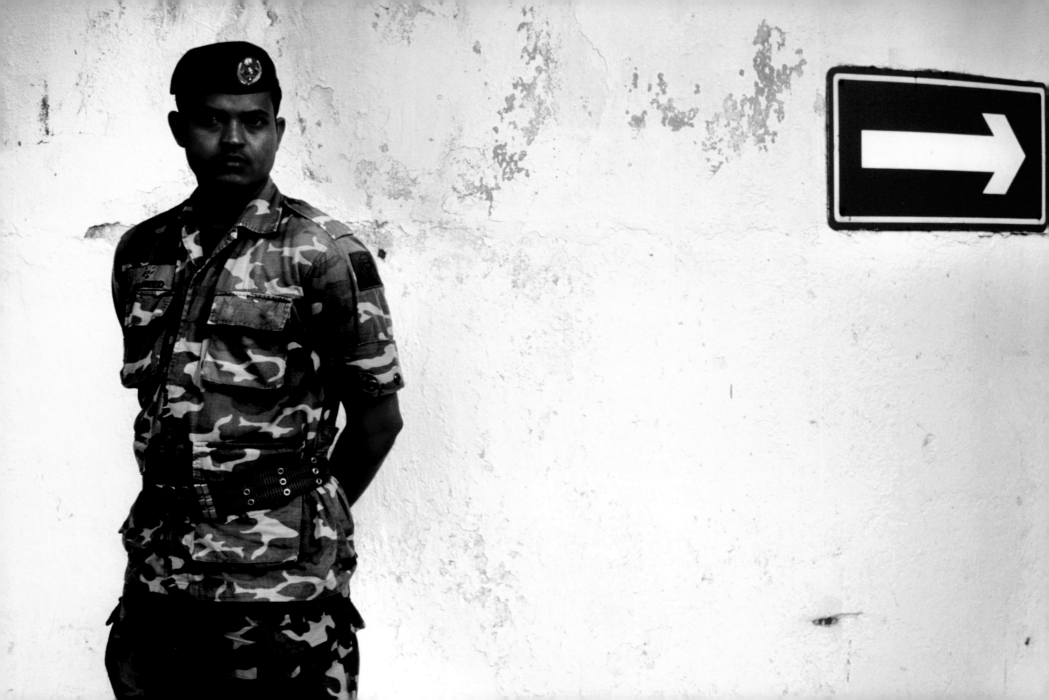

Very difficult to keep our priorities straight without
letting go of the games we play.

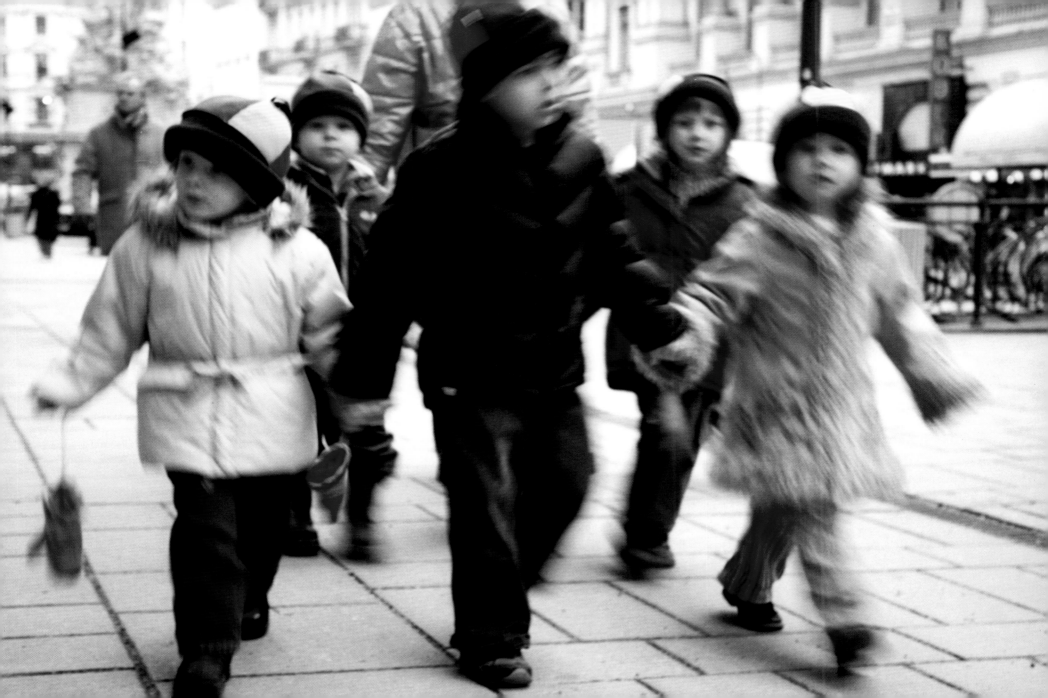

When you stand by your father because a sandstorm approaches, it seems obvious that ego has no place.

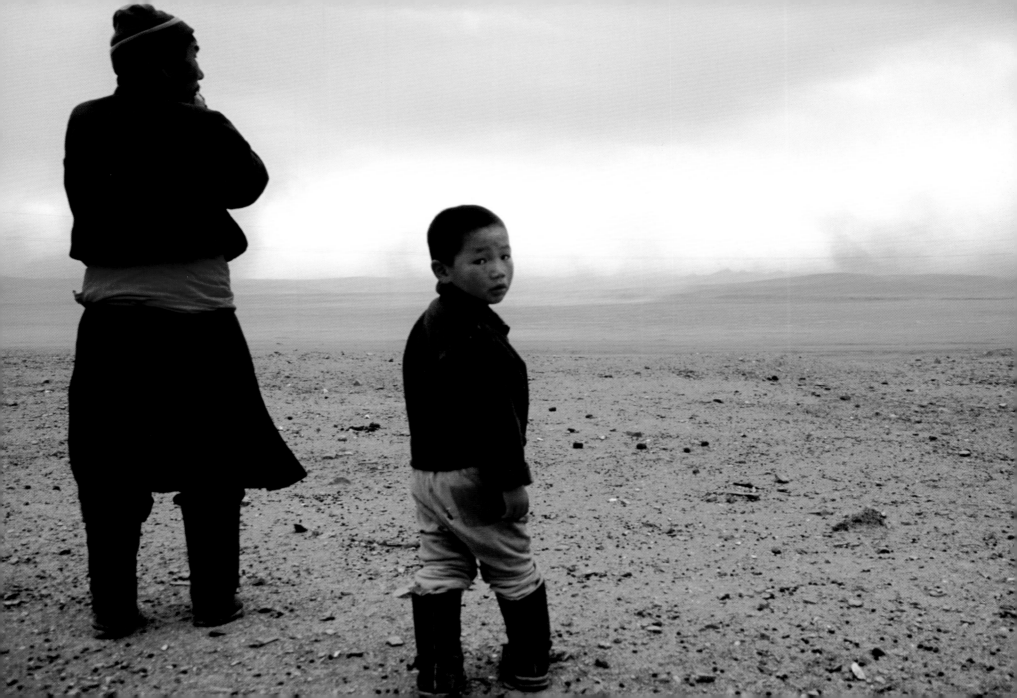

How can evil exist when we have the power of empathy?

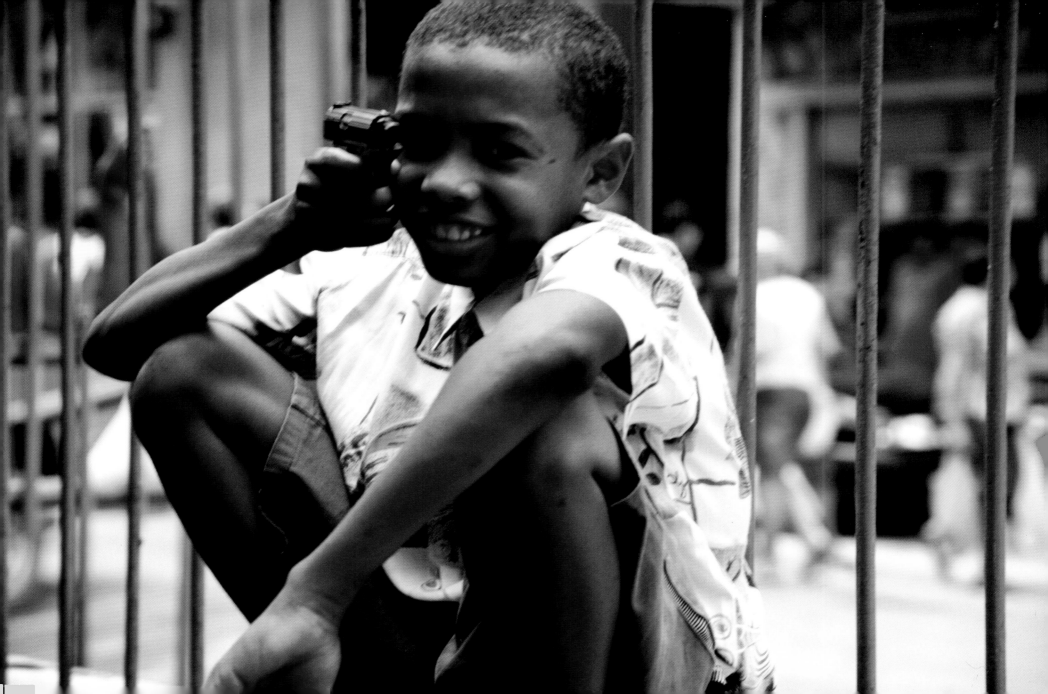

Anywhere you go, mothers and daughters would rather
live in peace.

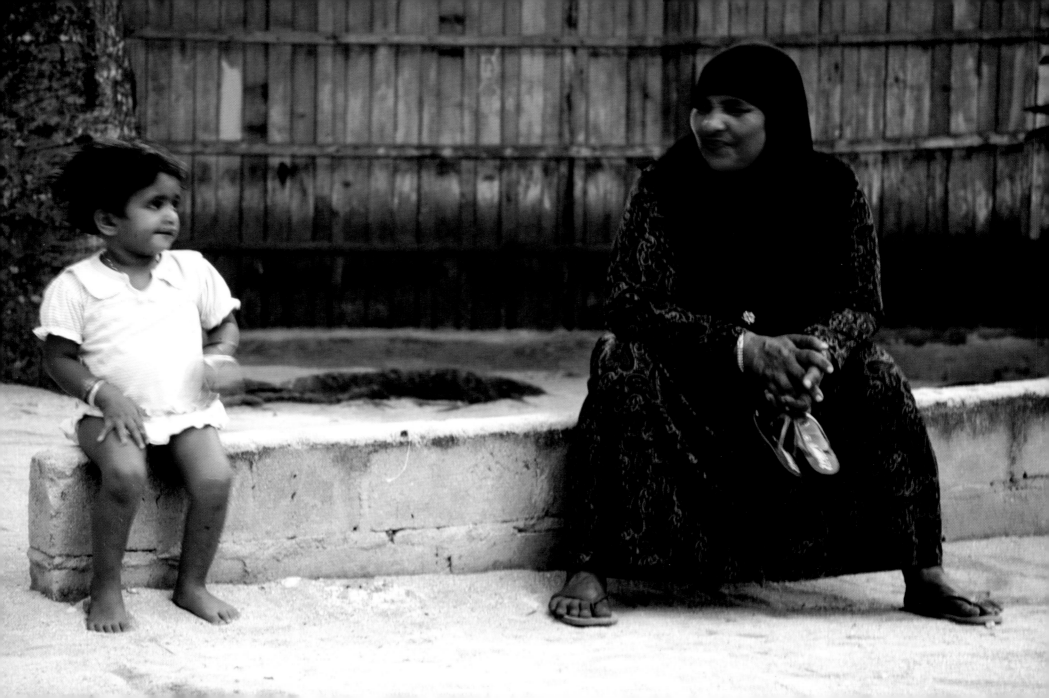

In both Worcester, Vermont, and Hovsgol, Mongolia, families gather each
evening around the wood stove and spend time together.

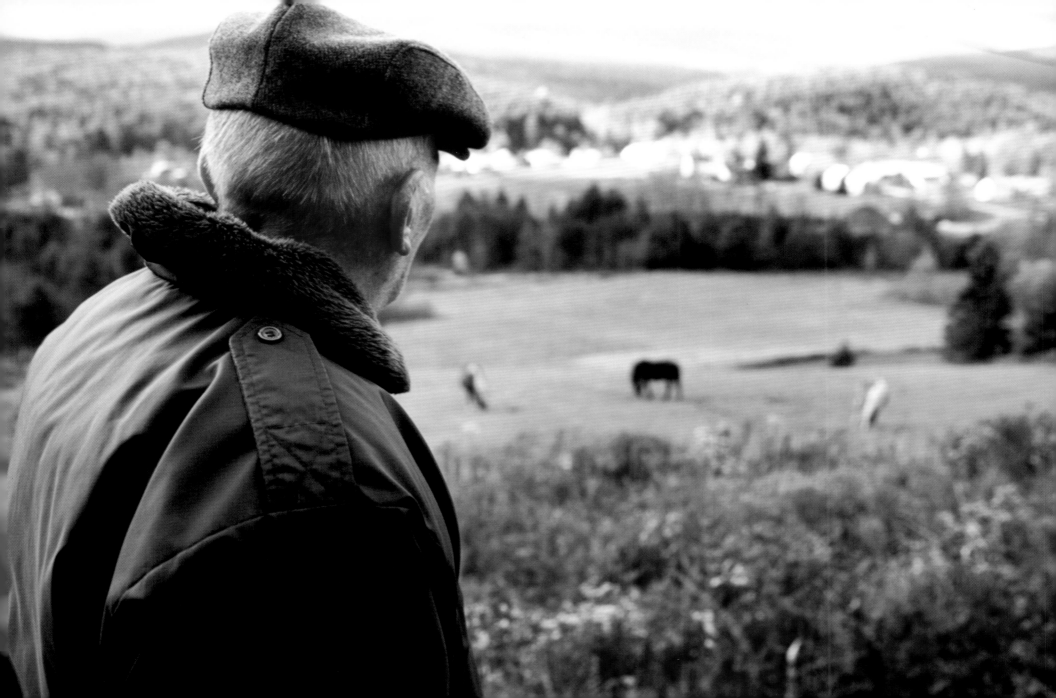

Neither of the extremes make much sense on their own.

Lose yourself in society, strive, struggle, succeed—
and you've spent your whole life chasing a ghost.

Break free, drop out, retire from the world—
and you've spent your whole life being the ghost.

Extremes naturally tend to collide.

Collisions balance conflicting forces.

Maintaining balance takes endless effort.

There's a certain air that engulfs you if you've asked the
right questions.

Then committed to something, anything, but managed to remember
it is not much more than just your choice.

The moment you erase the white board and look at all those previously unquestionable truisms fall apart can feel like a bottomless pit.

Psychology might call it anxiety.

Zen would call it nirvana.

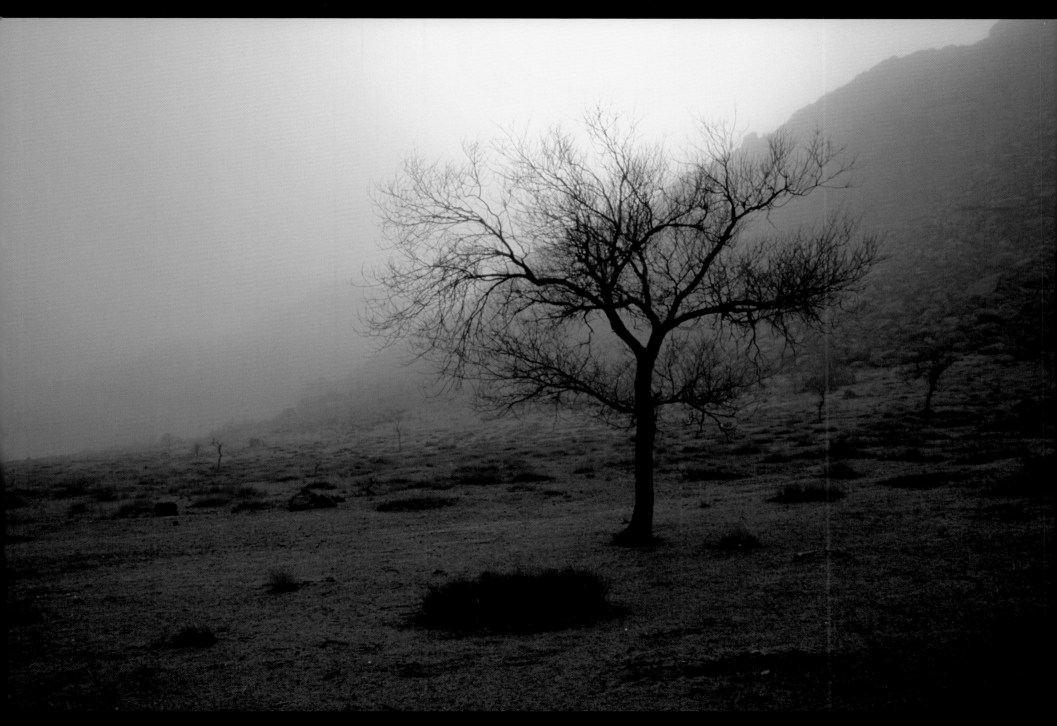

When you push on just past that first wave of fear,

embracing the void can be painful.

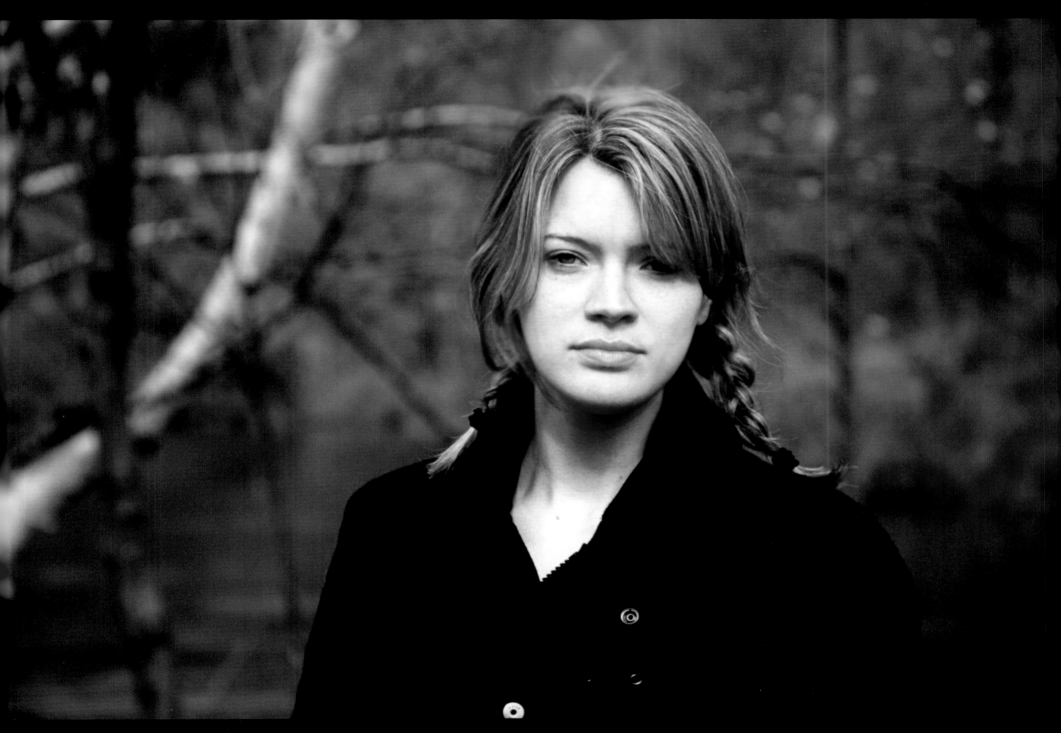

Can make you someone you never planned

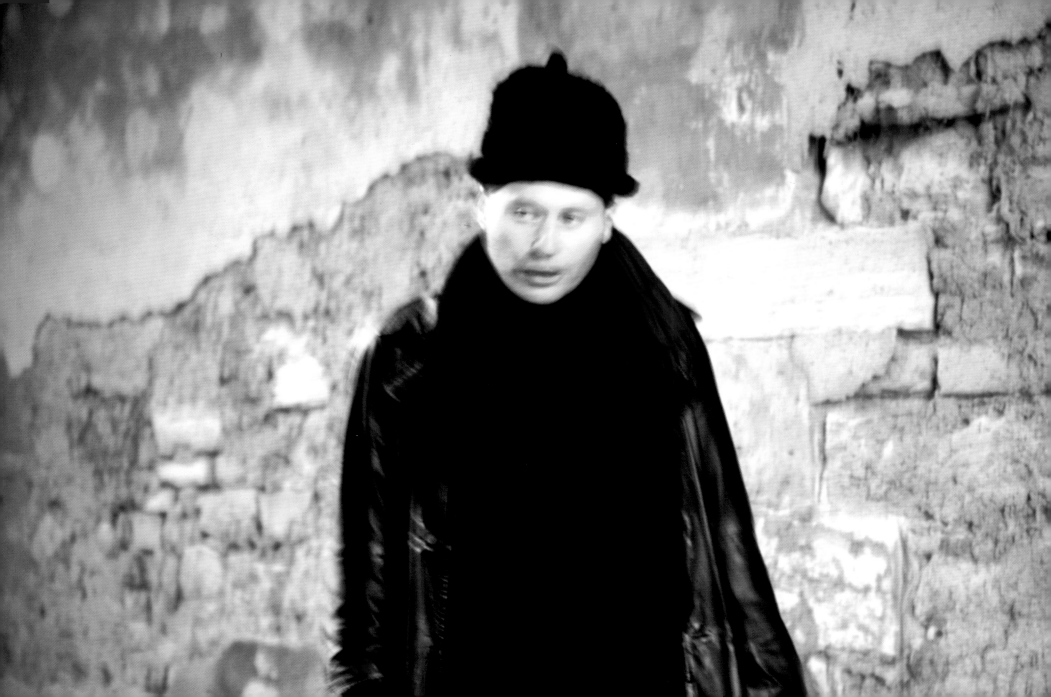

Though if you break free, the idea of anxiety can be a hard sell.

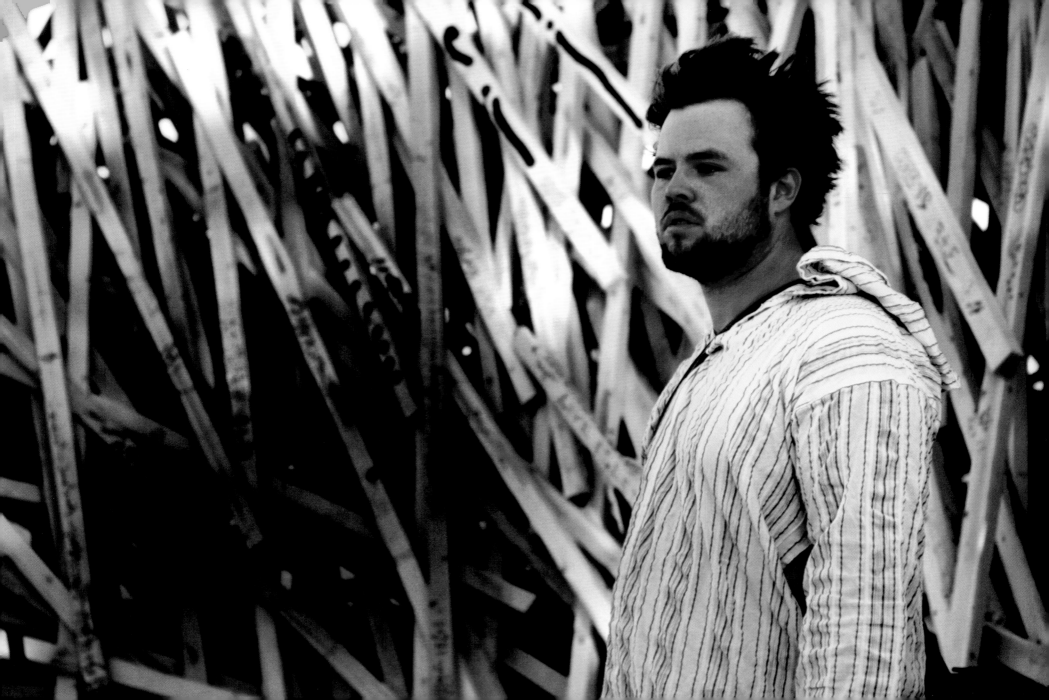

Life tends to be nicer when we choose our wants for
relevant and necessary reasons.

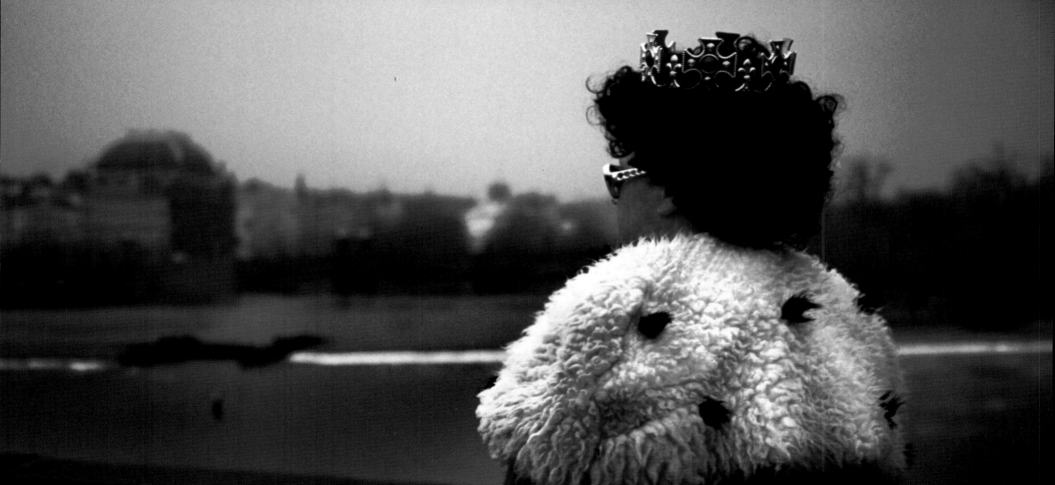

When you know your own deepest darkest secrets

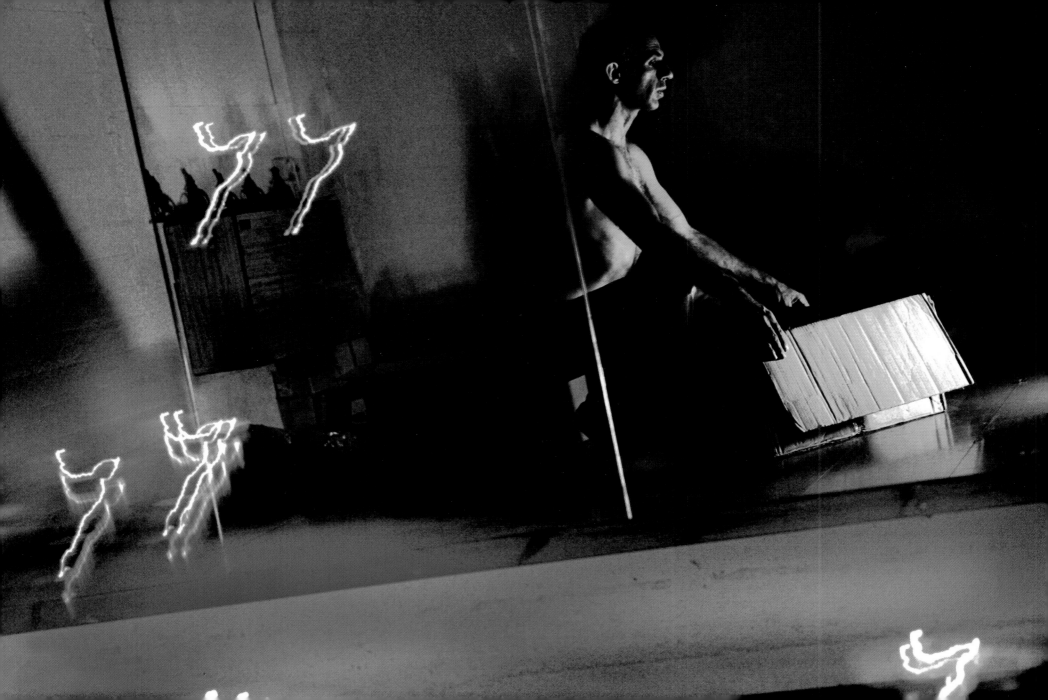

Make peace with your demons

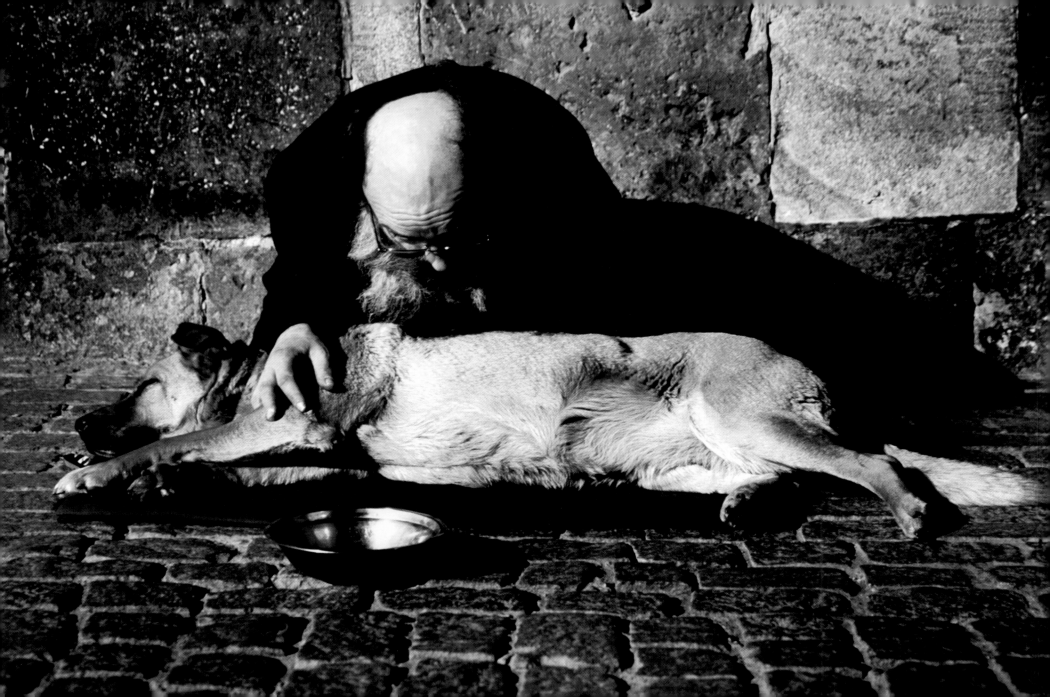

Reconcile the Extremes

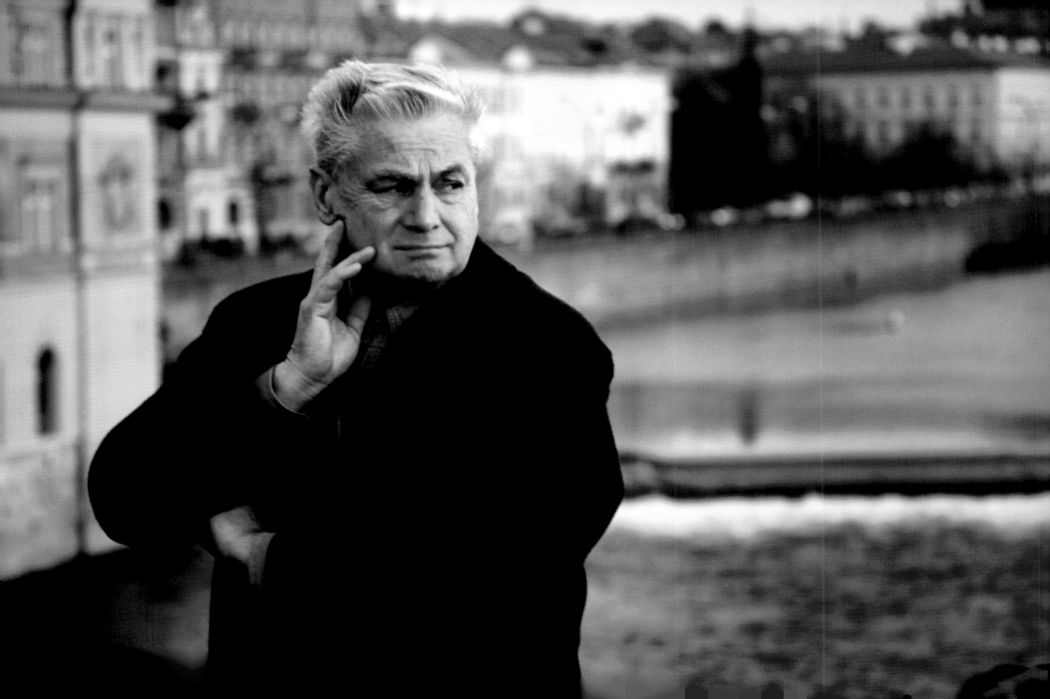

And hope for peace.

Good luck to us all.

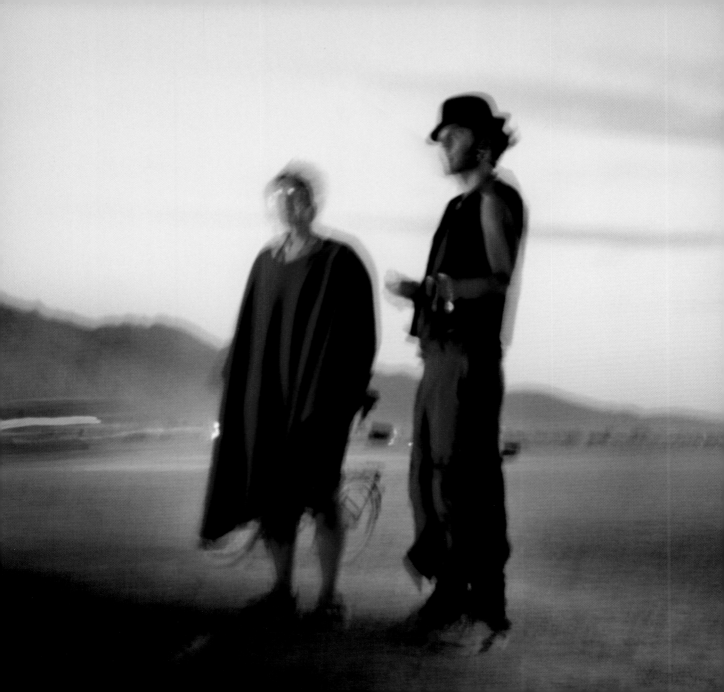

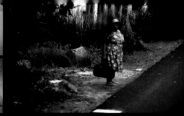
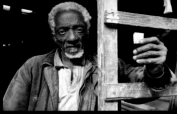
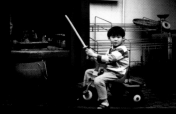
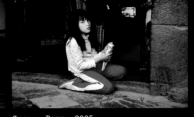
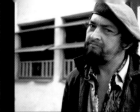

From top left clockwise:
Havana, Cuba. 2004; Israel, 2004;
Greenwich, Connecticut, US. 2005;
Havana, Cuba. 2004

Seychelles, 2004

Havana, Cuba. 2004

Tai O, Hong Kong. 2007

Cusco, Peru. 2005

Havana, Cuba. 2004

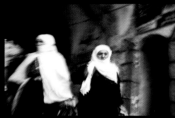
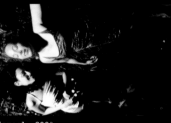
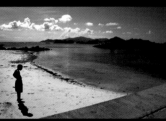
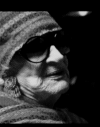
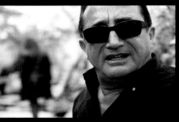
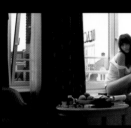

Jerusalem, Israel. 2005

Israel, 2004

Seychelles, 2004

Israel, 2005

New York, 2005

Amsterdam, Netherlands. 2007

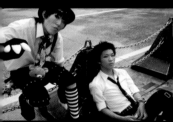
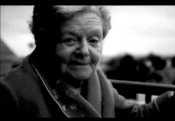
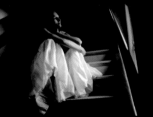
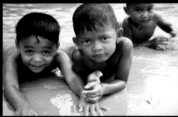
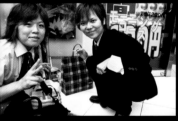
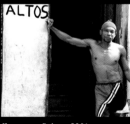

Tokyo, Japan. 2005

Israel, 2006

New York, 2005

Koh Lanta, Thailand. 2006

Tokyo, Japan. 2005

Havana, Cuba. 2004

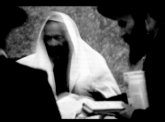
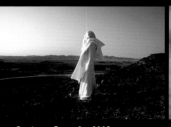
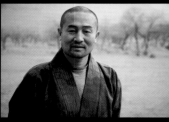
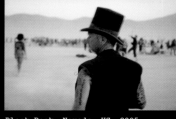
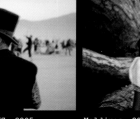
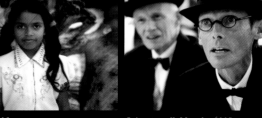

Jerusalem, Israel. 2006

Ramon Crater, Israel. 2005

Sunim Chan Sang, Mongolia. 2006

Black Rock, Nevada, US. 2005

Maldives, 2005

Scheveningen, Holland. 2005

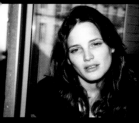 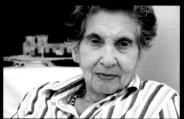 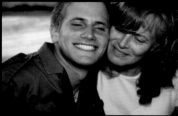 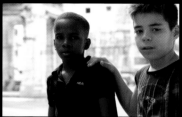 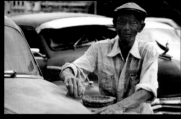 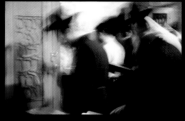

York, 2006     Israel, 2005     Israel, 2004     Havana, Cuba. 2004     Havana, Cuba. 2004     Jerusalem, Israel. 2005

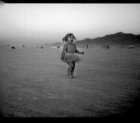 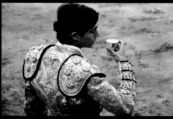 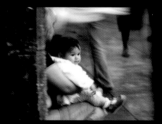 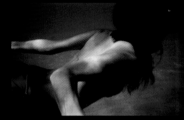 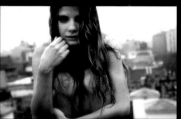 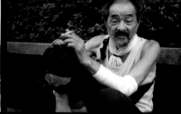

o, Peru. 2005     Lima, Peru. 2005     Cusco, Peru. 2005     Caribbean Sea, 2005     New York, 2005     Tokyo, Japan. 2005

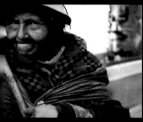 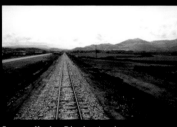 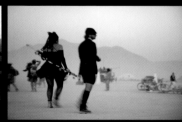 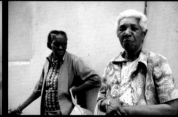 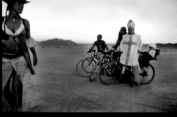 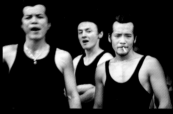

k Rock, Nevada, US. 2006     Cusco, Machu Picchu train, Peru. 2005     Black Rock, Nevada, US. 2005     Havana, Cuba. 2004     Black Rock, Nevada, US. 2005     Tokyo, Japan. 2005

  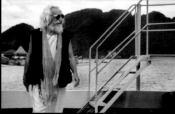 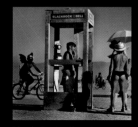 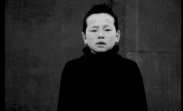 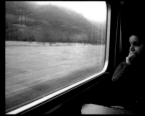

el, 2005     New York, 2006     Thailand, 2006     Black Rock, Nevada, US. 2005     Hovzgol, Mongolia. 2006     France, 2006

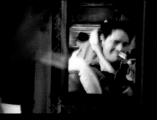
Paris, France. 2006

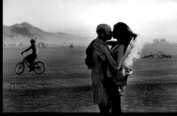
Black Rock, Nevada, US. 2006

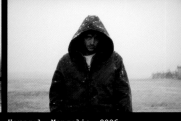
Morun, Mongolia. 2006

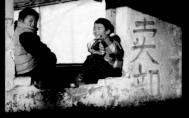
Hovzgol, Mongolia. 2006

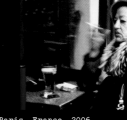
Beijing, China. 2006

Paris, France. 2006

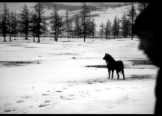
Hovsgol, Mongolia. 2006

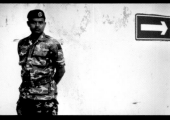
Male, Maldives. 2006

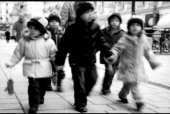
Vienna, Austria. 2006

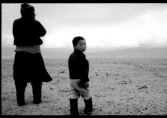
Mandalgovi, Mongolia. 2006

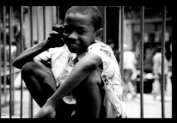
Seychelles, 2004

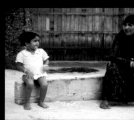
Maldives, 2006

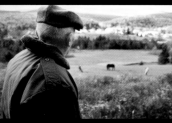
Worcester, Vermont, US. 2006

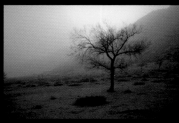
Mongolia, 2006

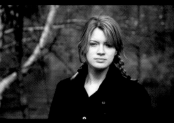
Worcester, Vermont, US. 2006

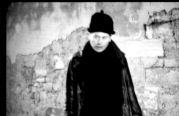
Paris, France. 2006

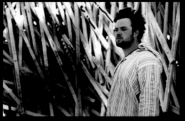
Black Rock, Nevada, US. 2006

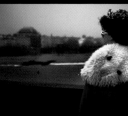
Prague, Czech Republic. 2007

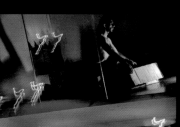
Israel, 2006

Prague, Czech Republic. 2007

Prague, Czech Republic. 2007

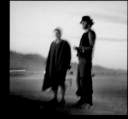
Black Rock, Nevada, US. 2006

Ohad Maiman was born in Israel in 1977; upon completing his
studies he served for 3 years in the IDF, traveled extensively,
eventually settling down in NYC in 1999. In 2003, he graduated
in philosophy and visual arts from Colombia University. He is
represented by CVZ Contemporary and lives and works in NYC.